The object of the Monitor

is to injure no man, but to bless all mankind.

MARY BAKER EDDY

ALL MANKIND

Photographs by Gordon N. Converse · R. Norman Matheny · Peter Main · Barth Falkenberg

Published on the occasion of the 75th anniversary of *The Christian Science Monitor*

Photo Edited by Jean I. Tennant

Design and Typography by Howard I. Gralla

ISBN 0-87510-145-3

Printed in the United States of America

CONTENTS

FOREWORD

When Mary Baker Eddy founded *The Christian Science Monitor* in 1908, she assigned its staff a simple but demanding task: "to injure no man, but to bless all mankind." Quite literally, the assignment of the *Monitor's* photographers is "all mankind." In pursuit of this goal, they do almost no orthodox photojournalism: fires, accidents, staged press events. Instead, they travel the world to capture, visually, the same elements of hope and progress that are recorded in the *Monitor's* written word.

Writing about the progress of mankind takes many forms. It deals with science: the effort of the race to understand more about the universe and to overcome physical limits. It deals with education: the unique ability of humans to transmit both knowledge and wisdom to succeeding generations. It deals with politics and diplomacy: the effort to overcome the faults of human nature and tribal behavior. It deals with economics: the effort to understand how work and resources can be organized to provide a better life for all. It deals with the arts: the effort to communicate beauty and ideas beyond the limitations of language.

In short, it deals with ideas and their effects.

For 75 years now, *Monitor* writers have tried to understand these forces that help determine the progress—or lack of progress—of the peoples who live on this blue marble suspended in space. *Monitor* writing has tried to help readers understand, to help them winnow out the important from the ephemeral, the ideas and facts that are lastingly useful as opposed to the manipulated or merely trendy.

But when all that writing is done, it is useful to *see* all men and women (as well as what they build and make, and how they live) in order to understand the brotherhood and sisterhood of man. For if this book is "about" anything, it is about humanity and light—the radiance of divine Spirit which illumines the brotherhood of man.

That's where the masterly staff photographers who currently rove the globe for *The Christian Science Monitor* do such a remarkable job. They bring back scenes for the family photo album. And in this case the family is mankind.

Chief Photographer Gordon Converse has traveled in some 112 countries during 40 years at his craft. Like his friend Ansel Adams, he has captured scenes of unforgettable wonder—including Earth's flora, fauna, architecture, and above all, faces.

Norman Matheny specializes in candid portraits of world leaders, people living bravely in war zones (Ulster, Zimbabwe, Korea), and slices of life in different cultures. Barth Falkenberg is a poet with nature, still life, and men and women at work. Peter Main usually covers subjects close to the New England hearth. Of the tens of thousands of pictures that have been taken, only a relatively few could be included in this book. Those selected have a timelessness and a dimension that makes us appreciate both the subject and the ideas it conveys.

What you see in this book is often beautiful or touching. What you don't see are the painstaking steps by which the photographer arrives at the exact moment he has frozen in time for you. Consider Gordon Converse on his way to take what were to be extraordinarily haunting photos of refugees in Laos—scenes of mother love and family closeness in the midst of the chaos of war.

In Cambodia he climbs into an ancient 28-seat Royal Lao plane at Phnom Penh airport. He slings his camera bag into the luggage rack, sits down, reaches for his seat belt. There is none. He switches to another seat, starts to cinch the belt around his waist. It comes loose in his hands. He moves again. The pilot taxis for his takeoff, revs the noisy old engine, starts, stops, taxis back to the terminal, opens the door and yells: "Forgot my radio! Could you hand it to me?" Again they taxi, rev, and at last lurch upward. The photographer's seat suddenly somersaults over backward. No bolts. But eventually riddled plane and floored photographer arrive at the refugee camp. A sample of the results: photographs 108 and 109.

Through it all—a total of some 88 years traveling through remote gorges, dangling over offshore drilling platforms, sledding in Antarctica, shooting from a hang glider, living with Eskimos in Greenland, landing on carrier decks, flying with the border patrol, bracing for a shot from a whitewater kayak—these *Monitor* photographers have felt protected despite the hazards. You cannot photograph the family at home in its corner of the universe without feeling close to the Creator.

EARL W. FOELL
Editor
1983

INTRODUCTION

Henry David Thoreau, no common observer, once wrote in one of his journals: "The question is not what you look at but what you see." The purpose of photojournalism at its best is to help mankind see—to see and understand and share this wonderful, richly diverse world we live in.

We are told that sight is a faculty and seeing an art. Seeing is especially an art when we attempt to look beyond the surface of what seems to be. As our planet, and mankind on it, spin in endless motion, still photographs give us time to pause and to see. Photographs provide a universal method of communication that breaks through the barriers of language so easily that no barrier seems to be there at all.

A photojournalist, having learned to read and write with light, records his story with a camera. He or she is an eyewitness to history. Today many people see news from all over the world through the photographer's eyes and lens. What that photographer sees, feels, and thinks is permanently reflected on film. How true Mary Baker Eddy's observation, "The picture is the artist's thought objectified" (*Science and Health with Key to the Scriptures*, p. 310).

Staff photographers of *The Christian Science Monitor* usually record from a different viewpoint than other news photographers. Many newspapers and publications use photographs to sensationalize or shock. The *Monitor* photographer's goal is the *Monitor's* goal—"to injure no man, but to bless all mankind."

Yet it is precisely because of the *Monitor's* unique approach to news photography that syndicated news services and individual newspapers have picked up hundreds of *Monitor* photographs for use in other publications. They find fresh views, journalistic depth, and hope in *Monitor* photojournalism.

As the reader looks through this collection of pictures from around the world, we hope it will be apparent that the *Monitor* photographers enter a country with compassion, love, and a desire for better understanding. With our cameras, we search for the truth of what is taking place and then photograph it with dignity.

A few years ago, while working in one of the Eastern European countries, it was necessary for me to remain overnight in a small village. The next morning, before the town was fully awake, I roamed its winding streets to get a feel for the town. The morning

was bitter cold; it must have been well below zero. Only a few people were venturing from their homes, but I knew from experience that there must be activity somewhere. Suddenly down behind the Town Hall, I discovered the local outdoor market being set up for the day. Dozens of people were gathering to buy and sell and exchange produce from their farms.

As I entered the little square, all activity seemed to stop. I was an outsider, an intruder. I did not belong. Their faces were grim and suspicious. For a few moments I hesitated and then moved in slowly, keeping my camera well hidden.

Eventually, their eyes began to soften. The atmosphere took on new warmth. Before long, I took out my camera and started to work, recording faces such as I had never seen. They were strong and wholesome, honest and dignified, rich in character. One of my subjects was a little old man with five withered apples neatly placed on a board in front of him. It was all he could spare from his farm.

An hour or so must have passed before I completed my picture coverage. As I turned to leave, I felt something being stuffed into my hand from behind. I turned quickly and discovered the little apple seller. He was giving me one of his precious five apples as a gift. As our eyes met, I felt he was saying, "Thank you for coming to visit us."

We are often asked, "How can the *Monitor,* with its unique goals, cover wars photographically?" The answer is simple: we cover them our way. The *Monitor* was one of the first newspapers permitted to reenter the nation of Bangladesh after an extremely savage war. The very day I was to leave, the wire service released a package of photographs from Bangladesh picturing some of the most shocking and brutal atrocities I had ever seen.

When I arrived, the ugly, open wounds of the nation lay before me; the picture was grim. My heart went out to the people of Bangladesh when I saw—and felt—their hurt. But as I searched, I found what I had come to find: a new Bangladesh emerging from the ruins everywhere. My findings on film showed new strength, not weakness; new hope, not despair.

The *Monitor* had picked up where other news media had left

off and carried out our mission to help the people of Bangladesh recognize new solutions for the problems before them.

No photographer can evaluate his or her own work with complete objectivity, no matter how honest the intentions. Too often the personal relationship that builds up between the photographer and his subject gets in the way. That attachment is something the observer seldom experiences. Photographers present their work to the observer for the observer's own interpretation. As Alfred Stieglitz once said: "Here is the equivalent of what I saw and felt. That is all I can ever say in words about my photographs; they must stand or fall as objects of beauty or communication on the silent evidence of their equivalence."

Primarily for this reason, the task of selecting the photographs for this book was placed in the hands, not of the staff photographers themselves, but of a book designer and a picture editor. Observing from the sidelines, I saw a number of old favorites fall by the wayside. "What are you looking for?" I asked.

"The wonderful challenge of this book," they answered, "has been to find those photographs that speak to us, and then to listen for the rhythm that would link them together."

Here are works by the staff photographers of *The Christian Science Monitor.* We hope they speak to your heart as they have to ours.

GORDON N. CONVERSE
Chief Photographer
1983

ALL MANKIND

Our true nationality is mankind.

HERBERT GEORGE WELLS (1866-1946)

THE AMERICAS

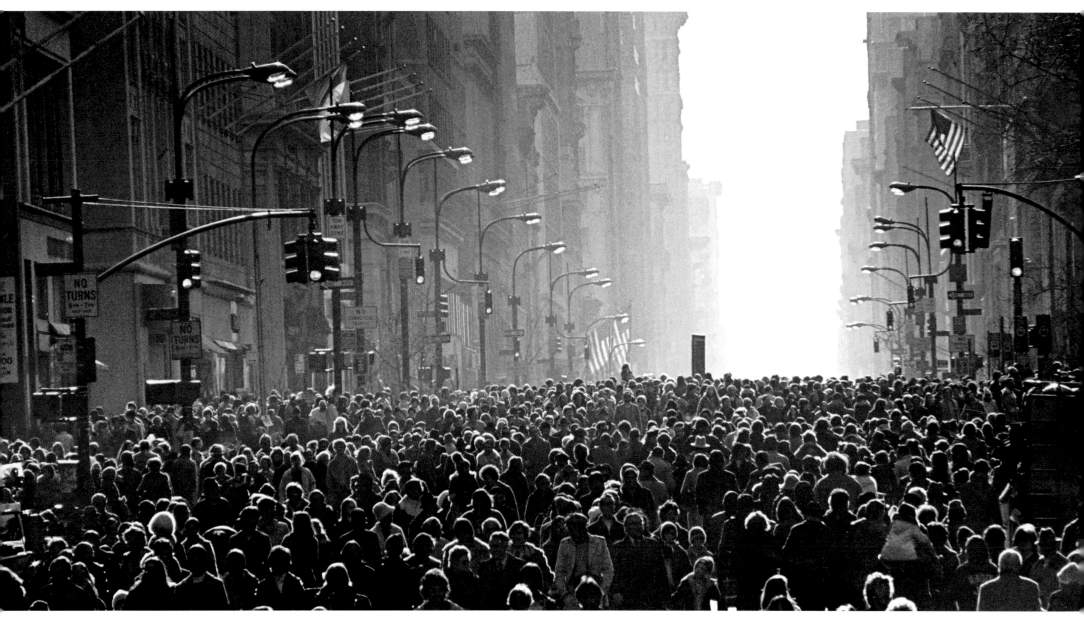

1. *New York, 1976*

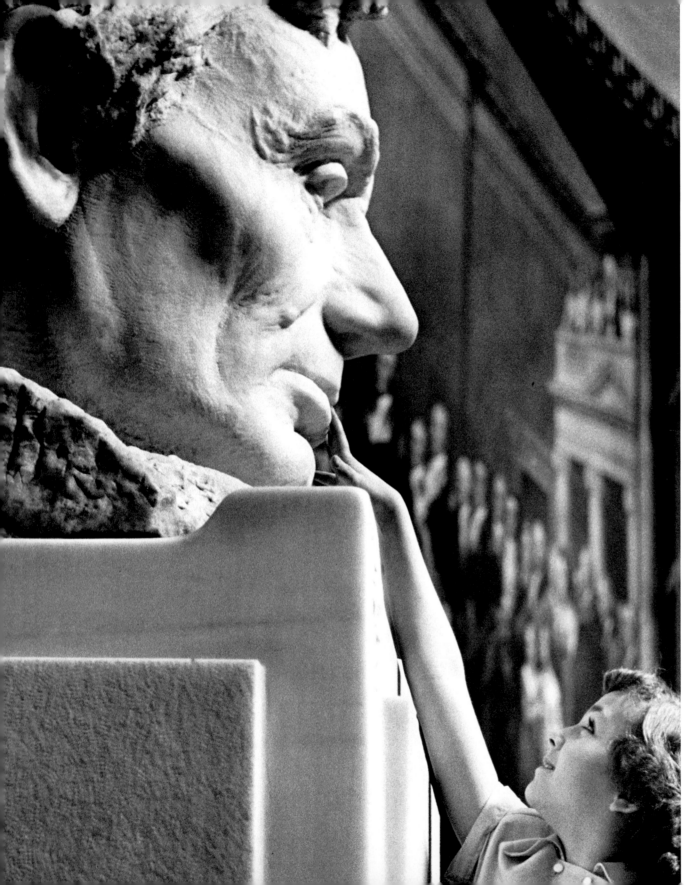

2. *Washington, 1960*

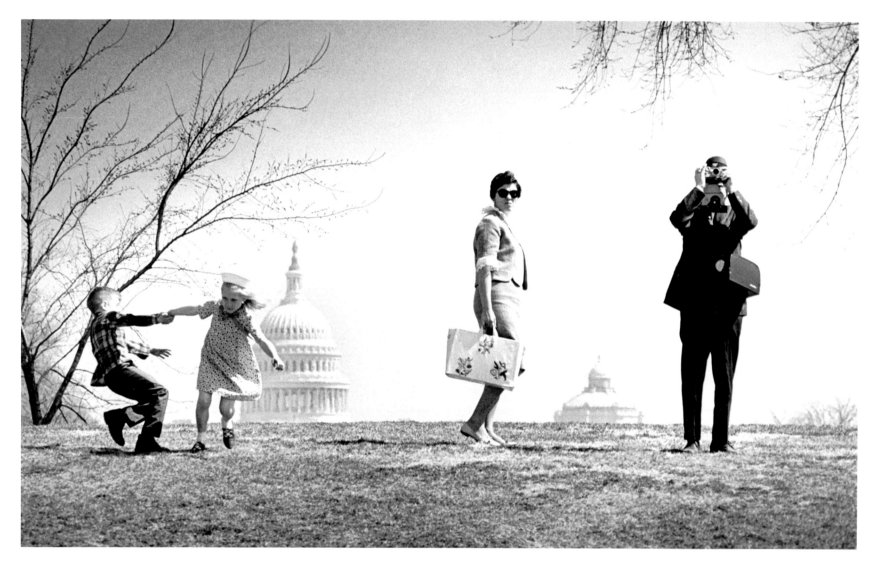

3. *Washington, 1969*

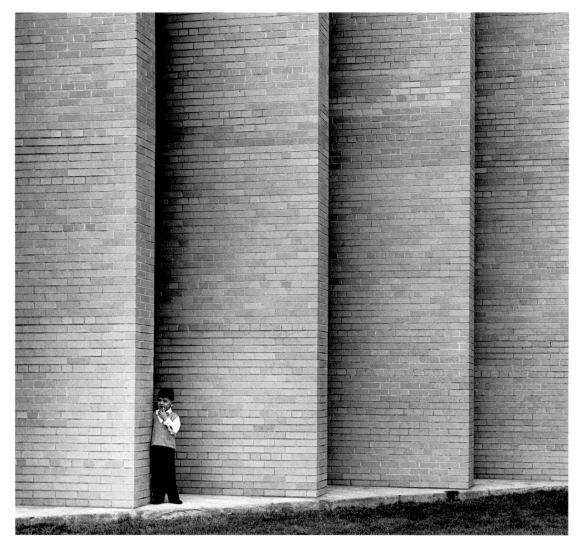

4. *Boston, 1969*

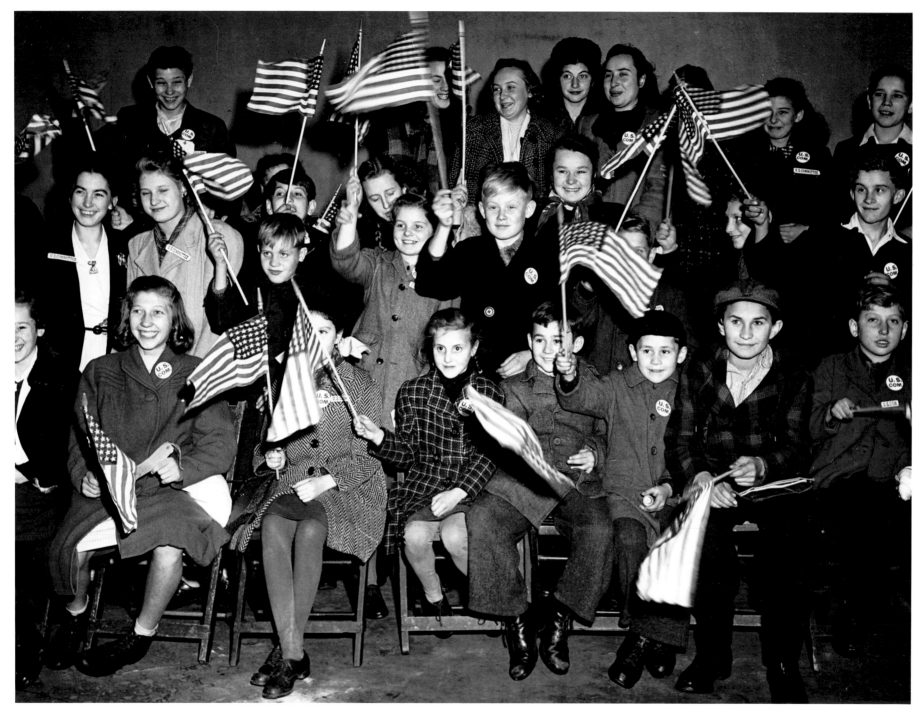

5. Boston, 1956

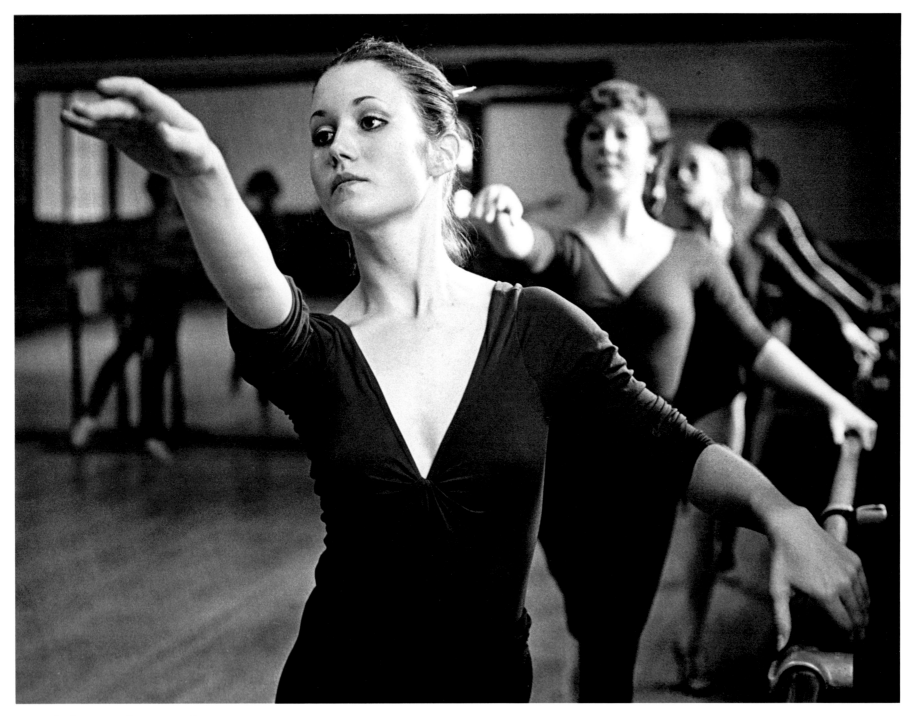

6. Cambridge, Massachusetts, U.S.A., 1981

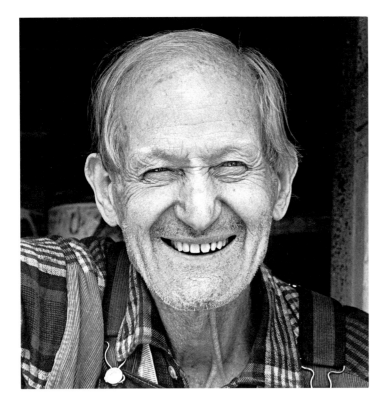

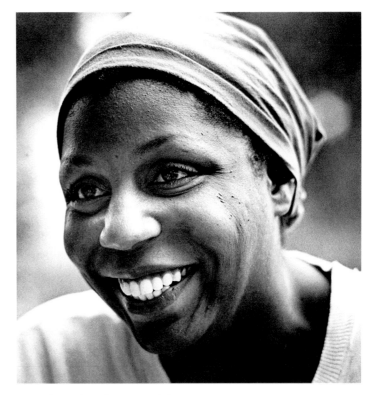

7. *Cape Cod, Massachusetts, U.S.A., 1973*

8. *Little Rock, Arkansas, U.S.A., 1977*

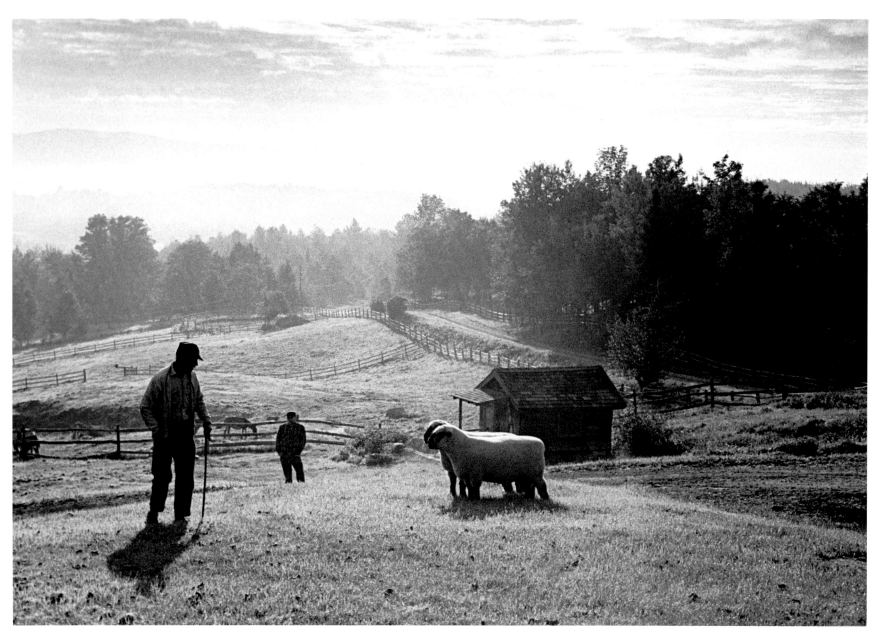

9. *Peru, Vermont, U.S.A.,* 1970

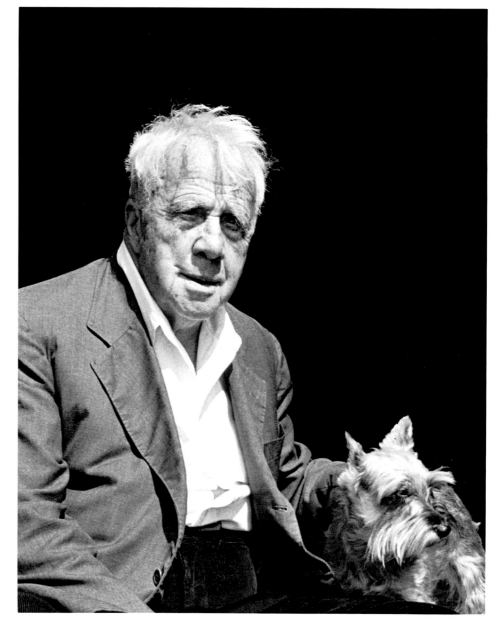

Nearly everybody is looking for something brave to do.
I don't know why people shouldn't write poetry.
That's brave.

ROBERT FROST (1874-1963)

10. *Cambridge, Massachusetts, U.S.A., 1955*

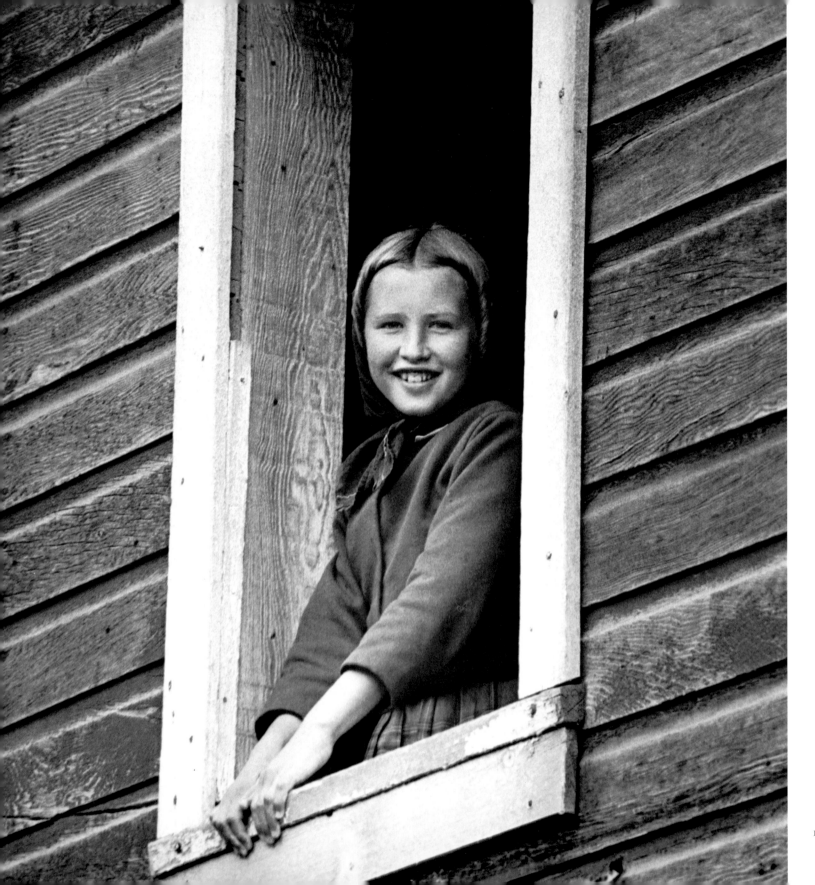

11. *Spring Creek Colony, Montana, U.S.A., 1977*

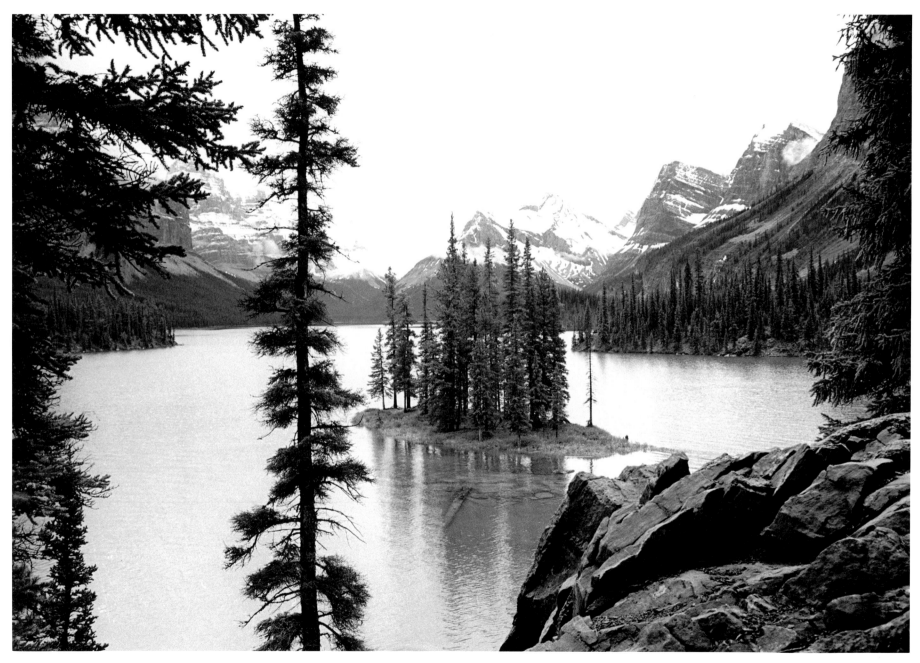

12. *Lake Maligne, Canadian Rockies, 1973*

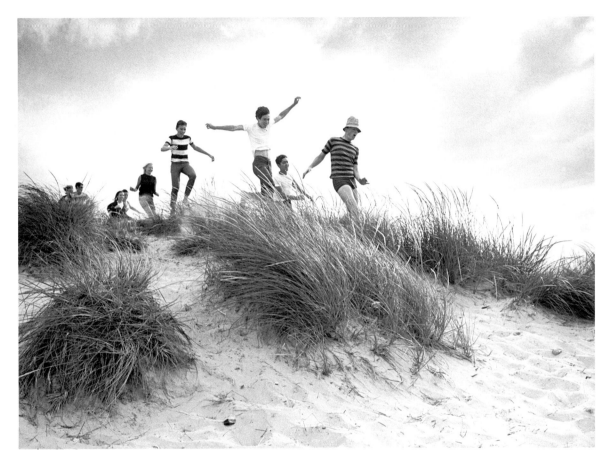

13. Indiana, U.S.A., 1967

14. Oregon, U.S.A., 1960

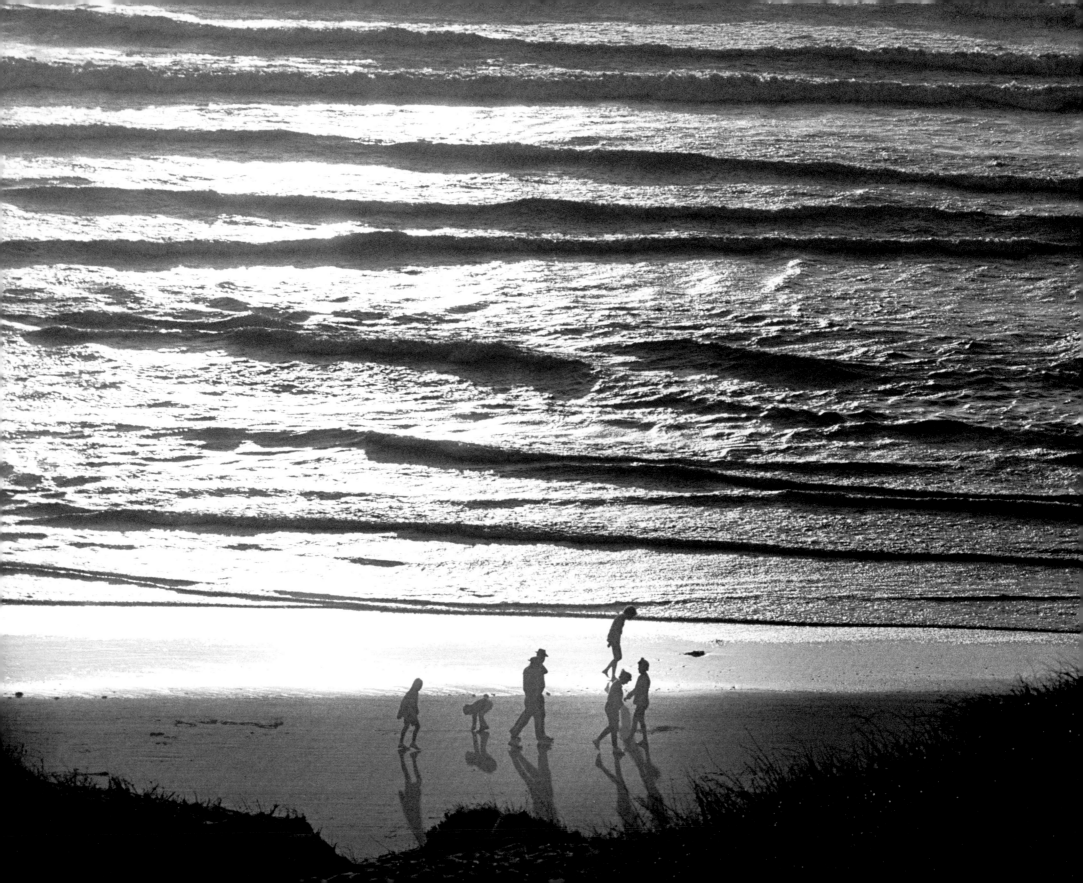

It might be said now that I have the best of both worlds, a Harvard education and a Yale degree. JOHN F. KENNEDY

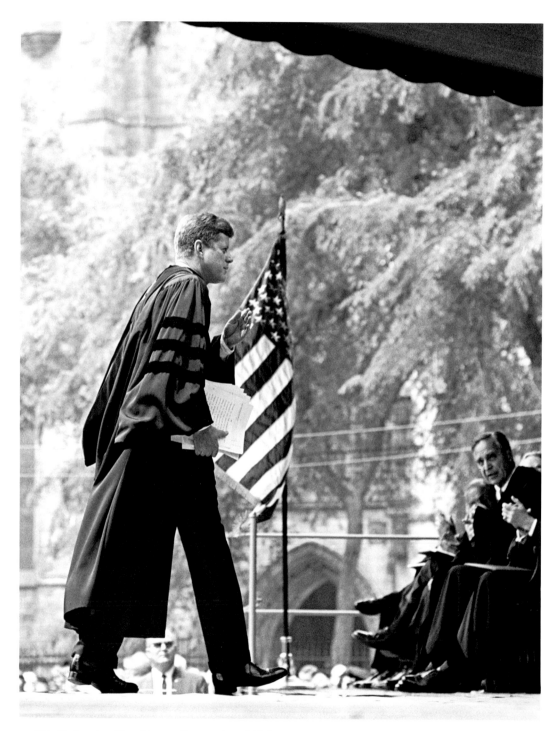

15. *Yale University, New Haven, Connecticut, U.S.A., 1962*

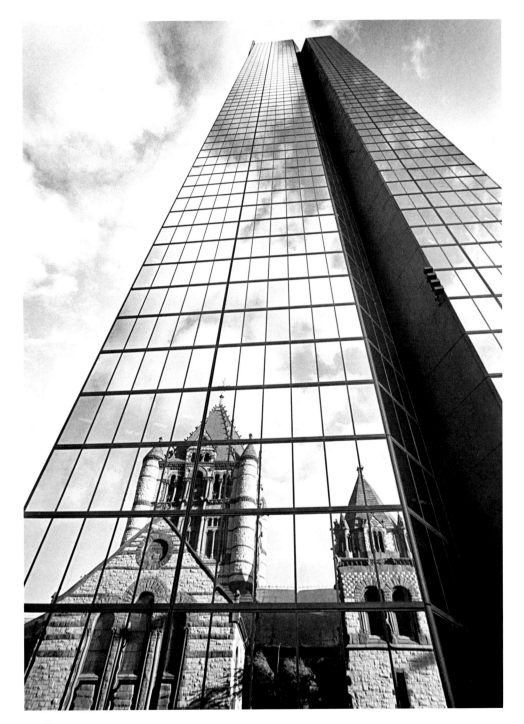

16. *Boston, 1977*

17. *Boston, 1976*

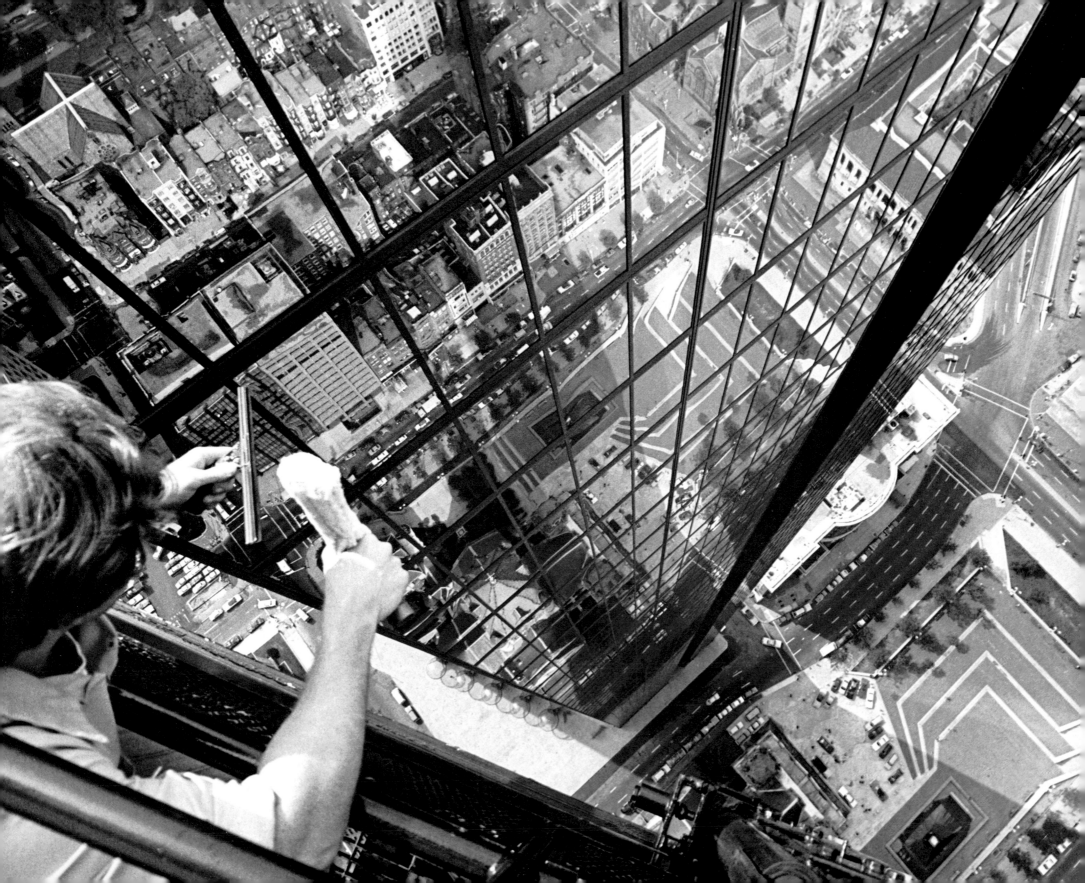

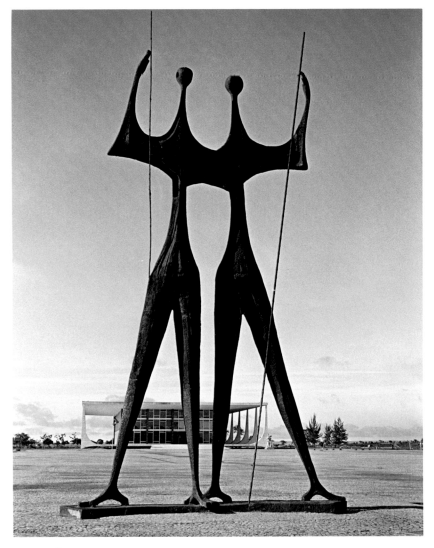

18. *Brasilia, 1967*

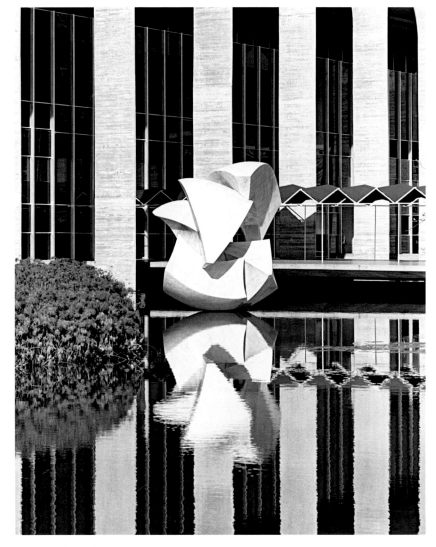

19. *Brasilia, 1967*

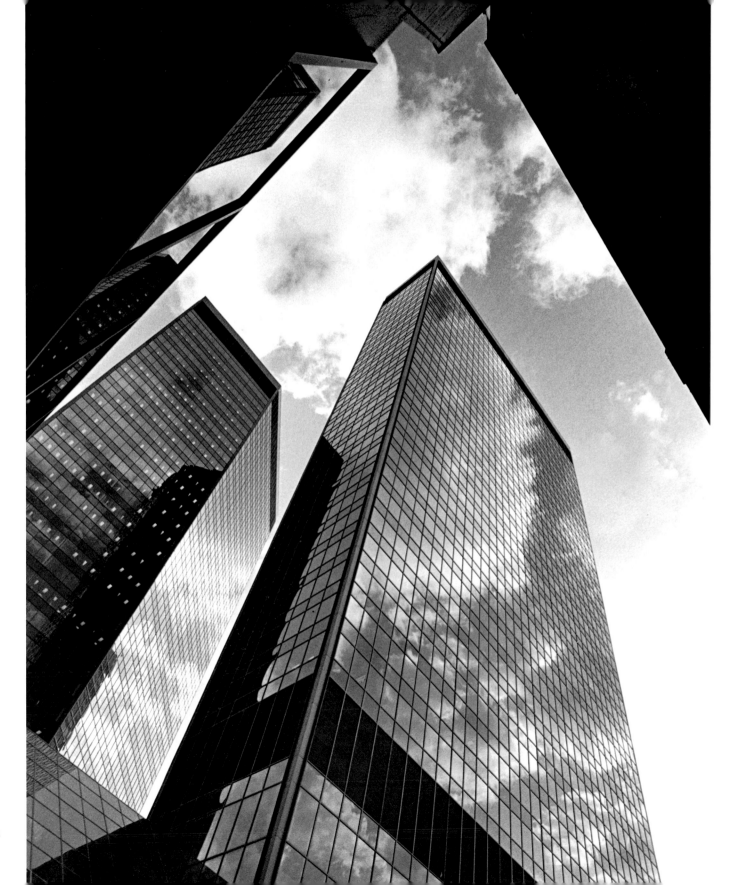

20. *Calgary, Alberta, Canada, 1982*

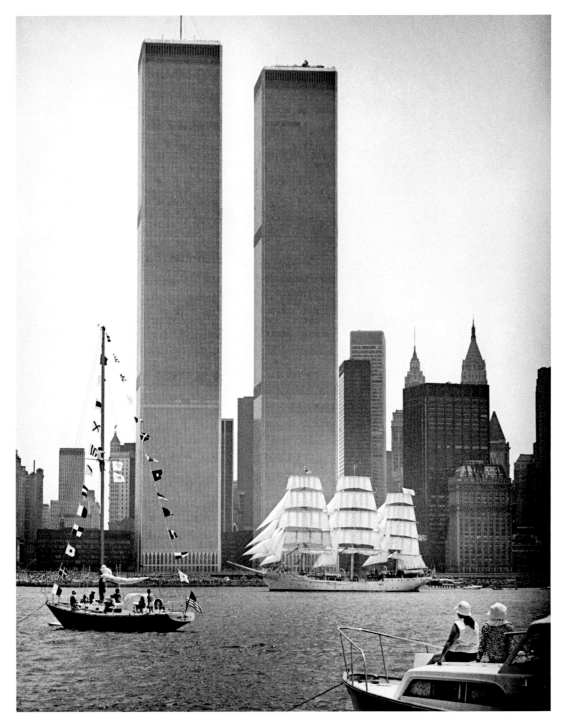

21. *New York, 1976*

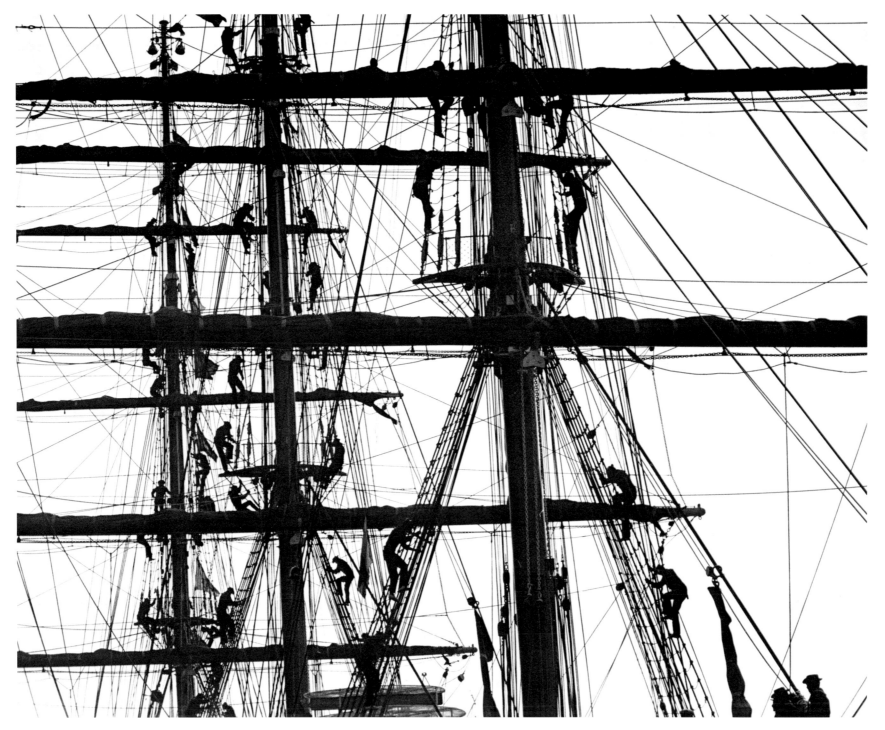

22. *New York, 1976*

July 4, 1976. It was America's 200th birthday and I had spent the day in New York City covering the "parade" of tall ships.

Back in Boston that evening, I headed directly for my darkroom to develop the film for our next deadline. The narrow streets were packed with people on their way to the banks of the Charles River to hear a special concert by the Boston Pops. Hanging my film up to dry, I decided to walk over and try to photograph the fireworks display that would mark the end of the city's celebration of the Bicentennial.

Outside the *Monitor's* offices a blind man was trying to cross the street amidst the confusion of the crowd about him. I offered him my arm, and as we moved off, he felt the camera bag over my shoulder and asked if I was on my way to photograph fireworks. I explained I had hoped to, but there were so many people I didn't think I'd find a place to get a good shot. He then invited me to a party on top of his apartment building overlooking the river. I couldn't have had a better view in the entire city.

As we listened to the concert high above the noisy crowd, the 1812 Overture came to a close and the entire sky lit up with one final spectacular display of fireworks.

I have often thought of that kindly man who could not see, yet had the insight to lead me to a front-page picture.

Barth Falkenberg

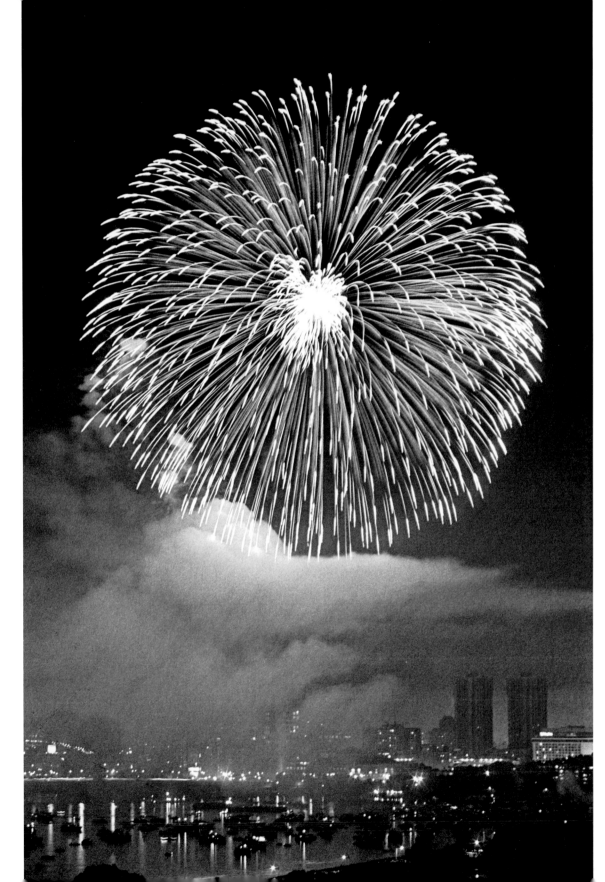

23. *Boston, 1976*

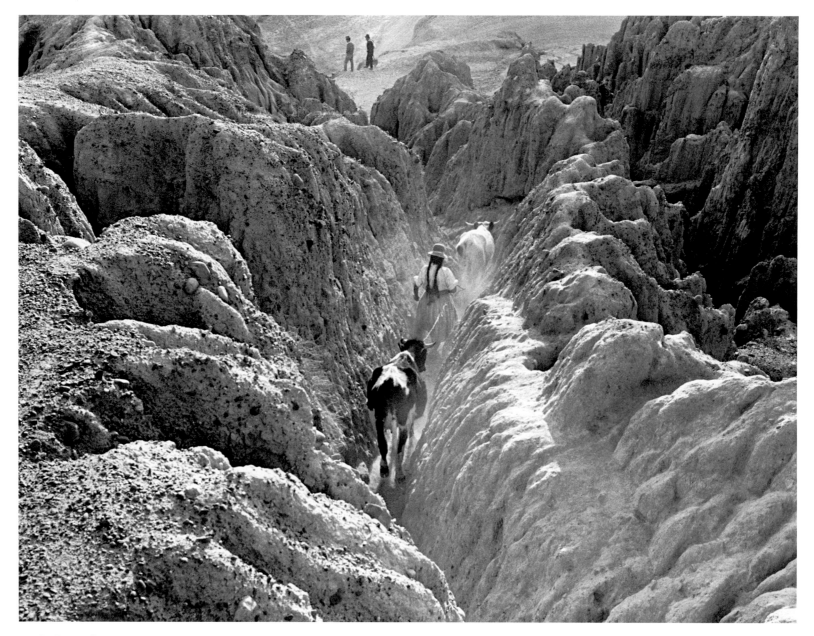

24. *La Paz, Bolivia, 1967*

25. *La Paz, Bolivia, 1967*

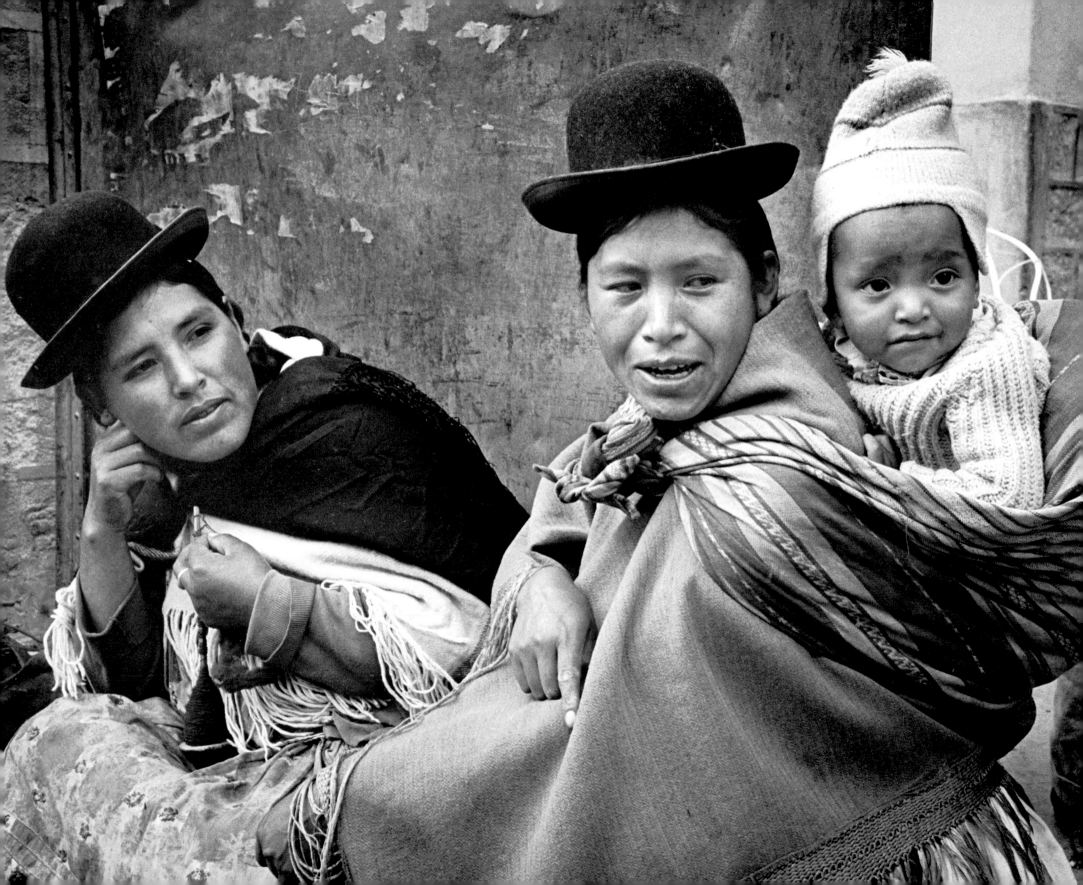

The fog comes
on little cat feet.
It sits looking
over the harbor and city
on silent haunches
and then moves on.

CARL SANDBURG (1878-1967)

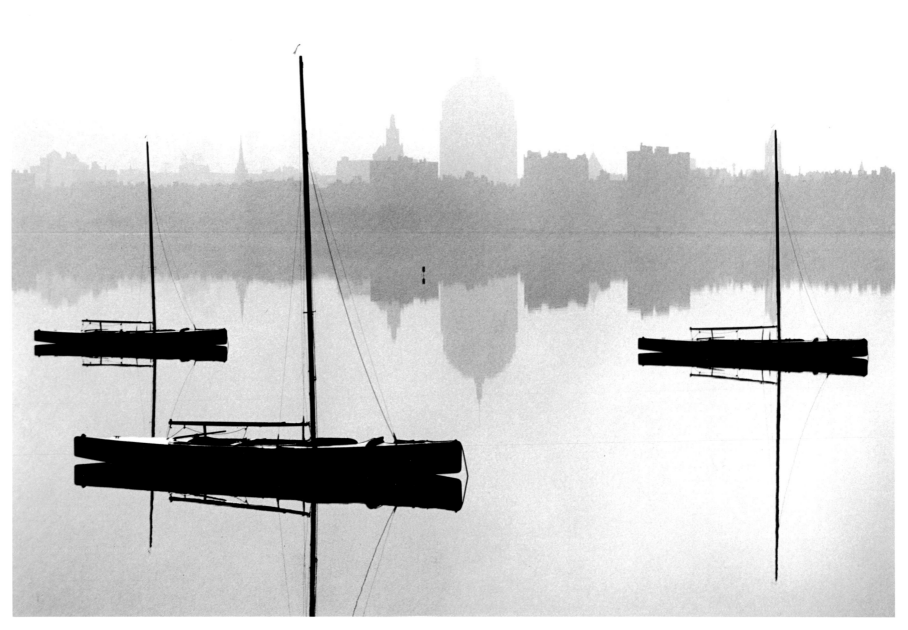

26. *Boston, 1958*

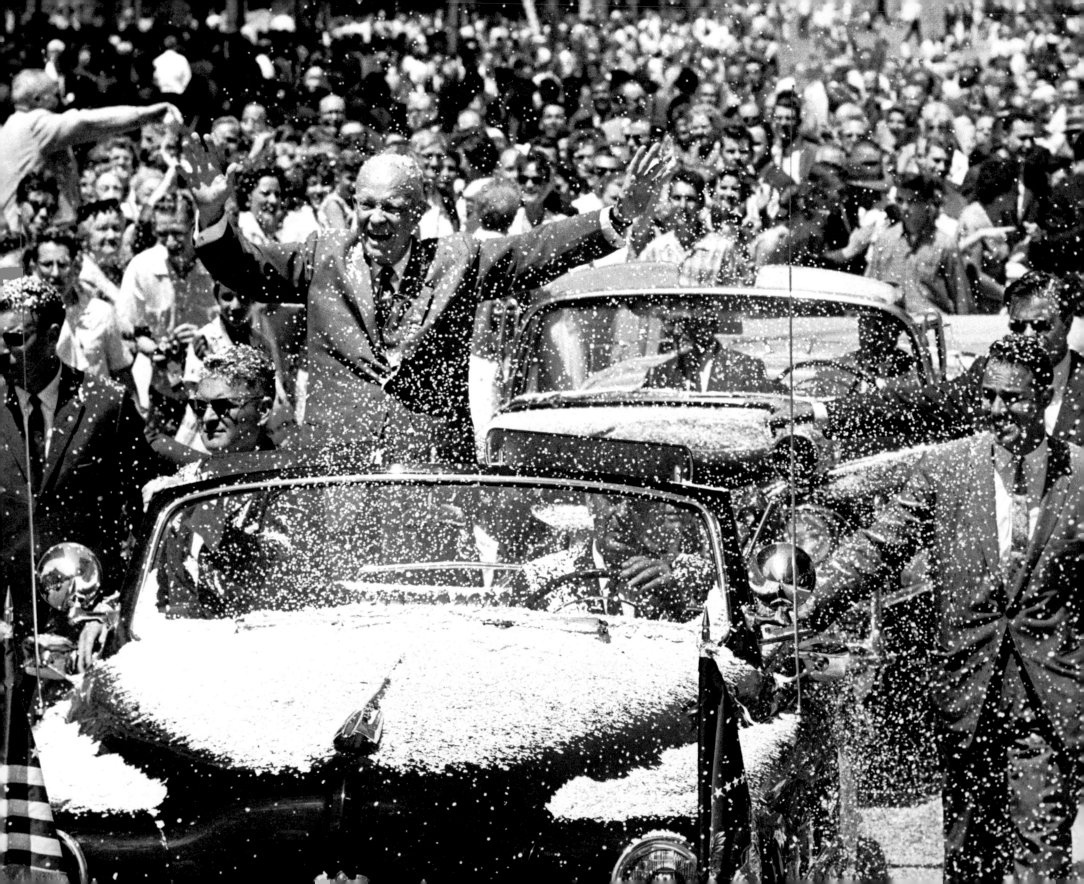

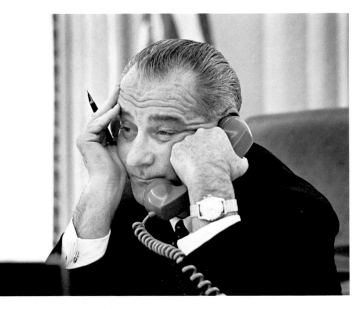

28. *The White House, Washington, 1963*

President Eisenhower was in Chicago for the Republican Convention, and the city was giving him a ticker-tape parade. It had started when I hustled onto the press truck only to find it had three sides and a roof. Dozens of photographers climbed aboard pushing me further inside; heads completely obstructed my view. I could not see the cheering world around me. Suddenly, our driver jammed on his brakes throwing most of the photographers to the floor. For the first time I could see the President, the Secret Service agents, and the people of Chicago. With my telephoto lens I caught it all—my one and only photograph of the event.

Within a few days after Lyndon Baines Johnson suddenly became the 36th President of the United States, he moved into the White House. I was one of the very first newspeople to spend an entire day photographing him.

Gordon N. Converse

27. *Chicago, 1960*

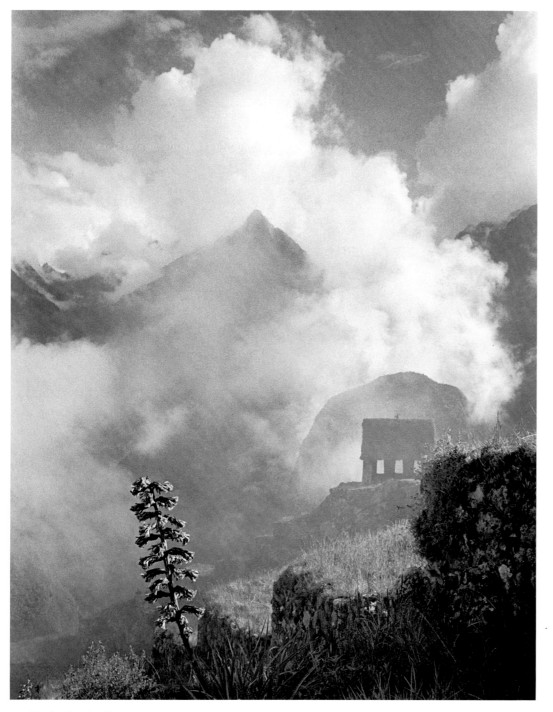

29. *Machu Picchu, Peru, 1968*

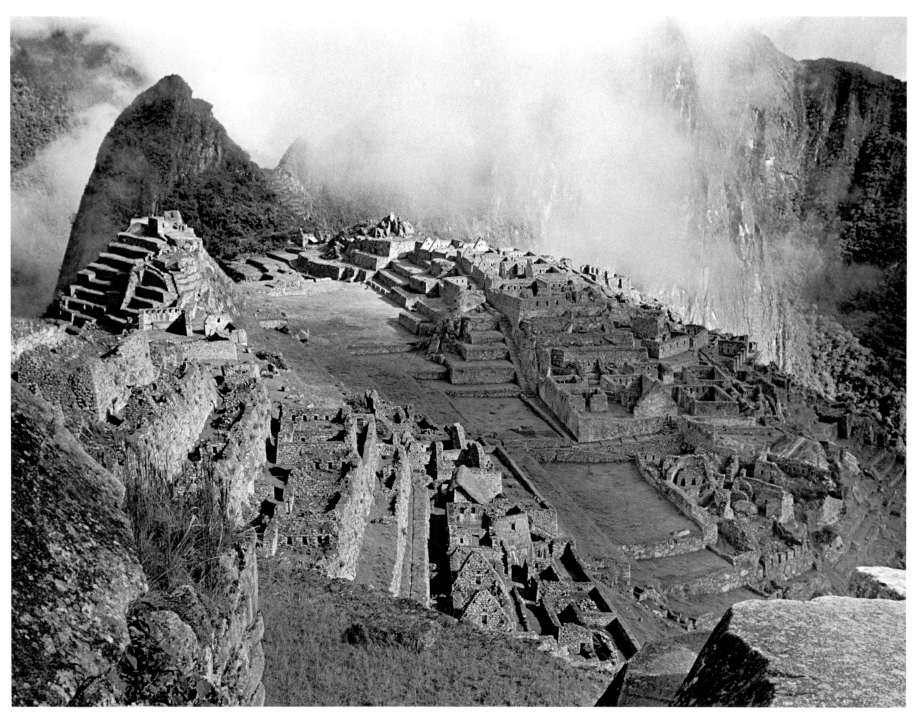

30. *Machu Picchu, Peru, 1968*

31. *Westwood, Massachusetts, U.S.A., 1975*

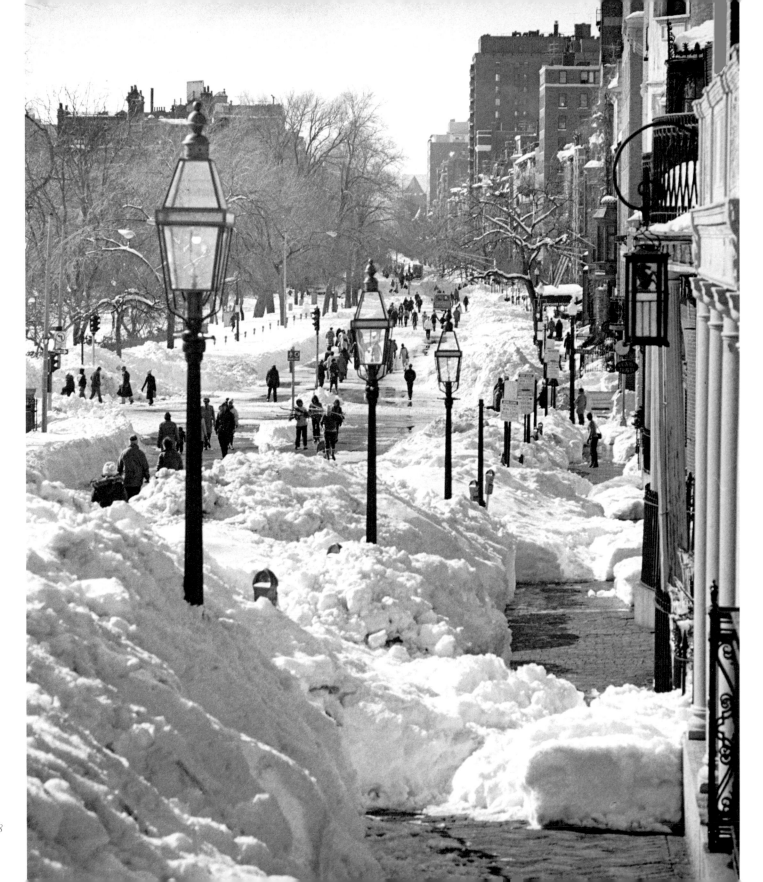

32. Boston, 1978

I came across four Massachusetts farm boys and their friend "Hooker," playing in stacks of hay on a new interstate highway under construction. School was out and cares were few as the boys jumped nimbly from stack to stack. Tail wagging, Hooker followed, watching and barking.

Warmed by the sun, at peace with the world, the boys plunked down on the hay and Hooker eagerly joined them. Simultaneously they slumped onto his back and he obligingly let them.

Peter Main

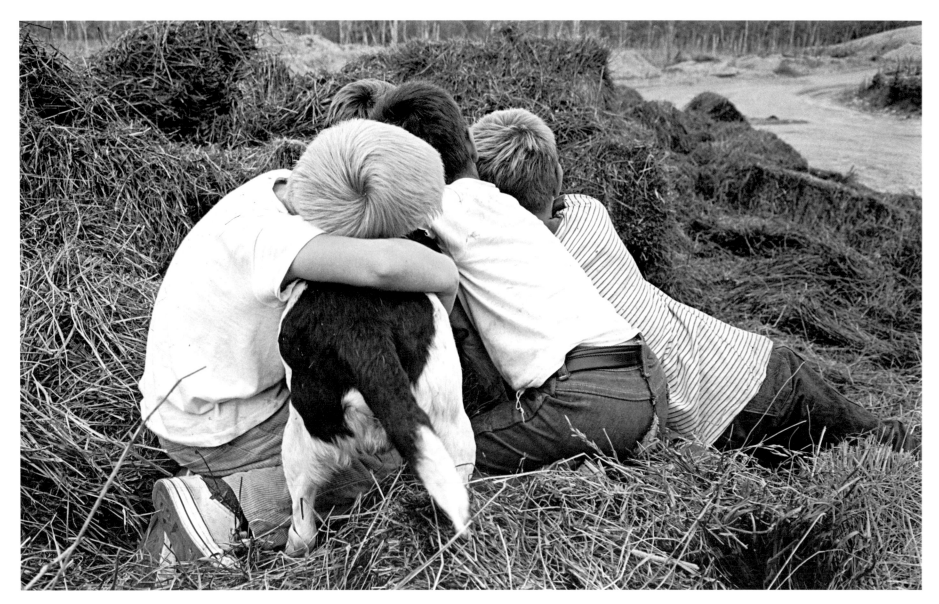

33. *Wrentham, Massachusetts, U.S.A., 1968*

Now stay in that chair…and she did!

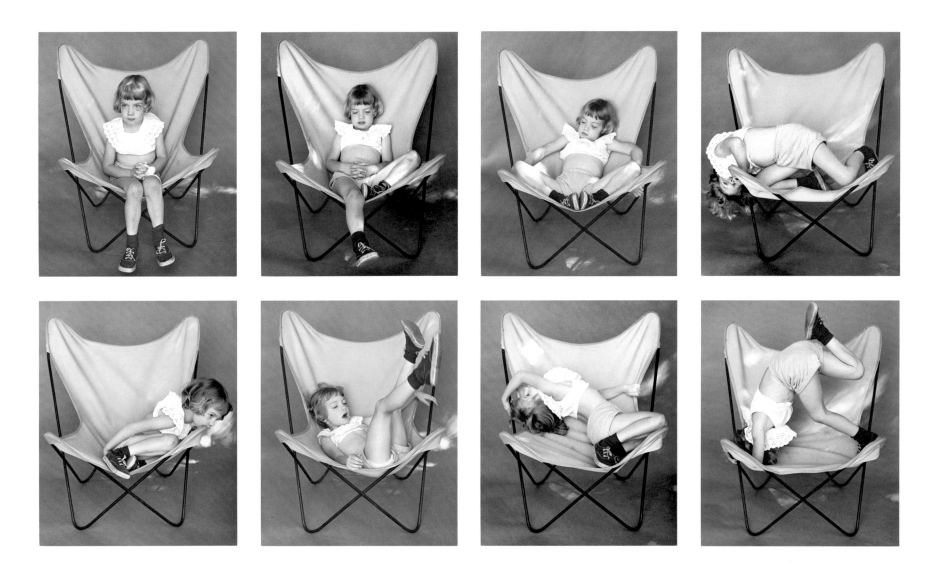

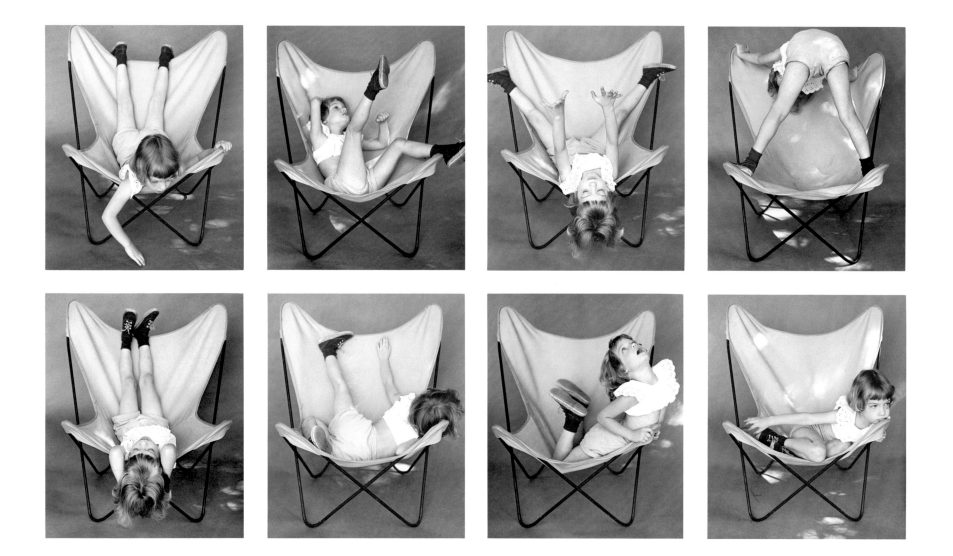

34. *Needham, Massachusetts, U.S.A., 1955*

Take its passport away from it and you wouldn't be able to tell a Soviet turkey from an American turkey. NIKITA S. KHRUSHCHEV

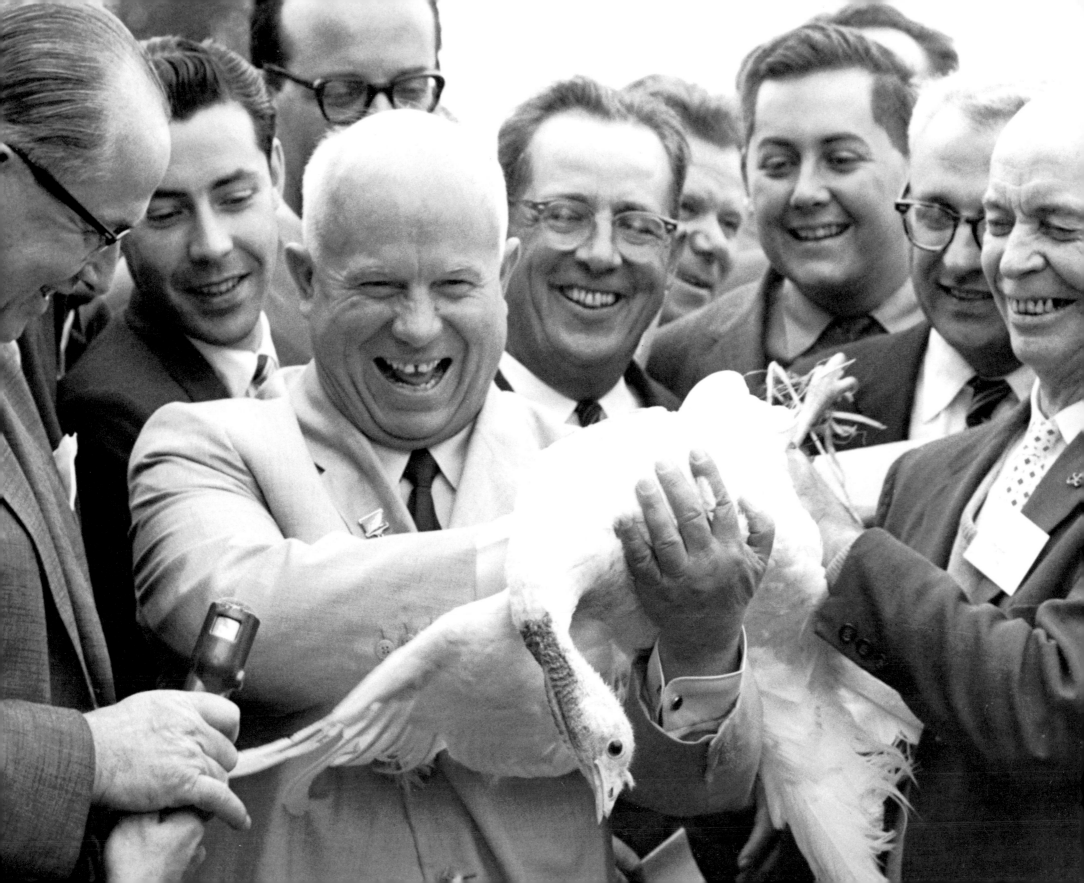

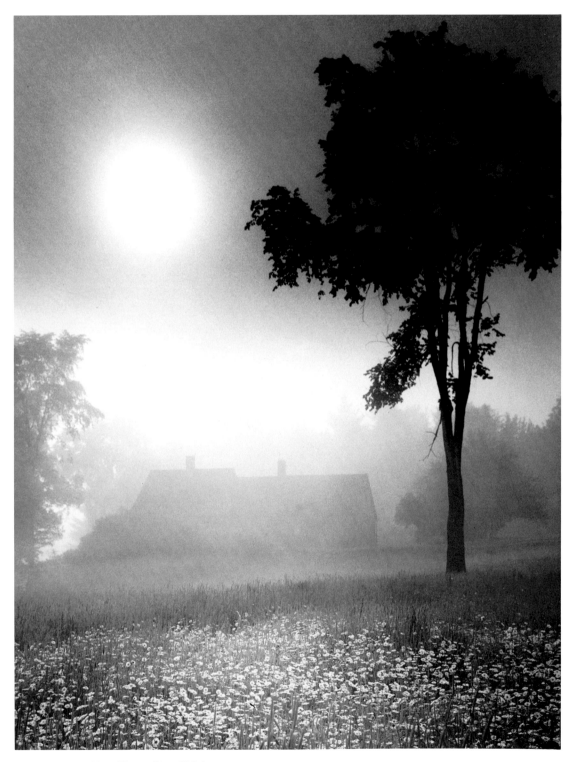

36. *Franconia, New Hampshire, U.S.A., 1967*

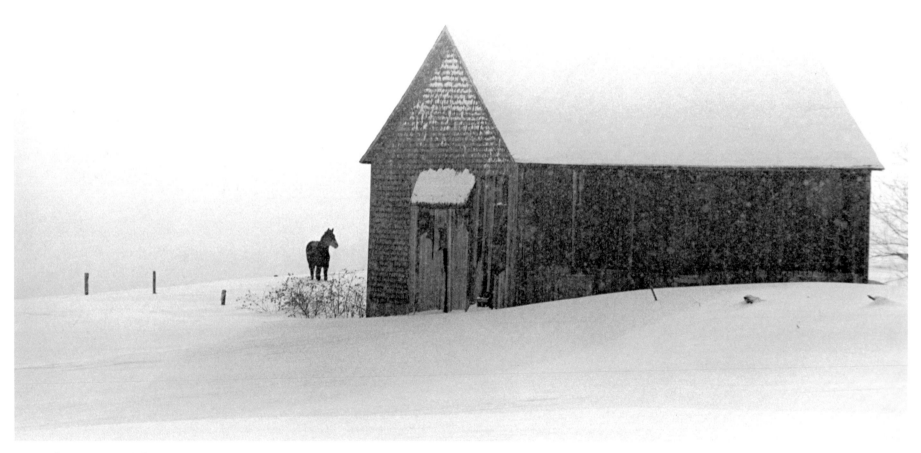

37. *Houlton, Maine, U.S.A., 1977*

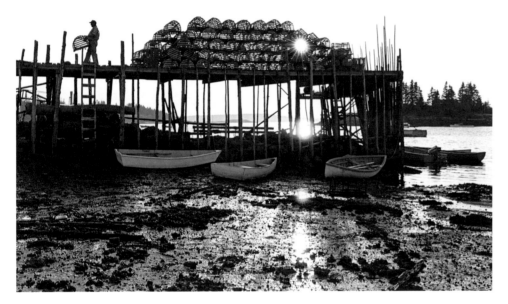

38. St. George's Peninsula, Maine, U.S.A., 1963

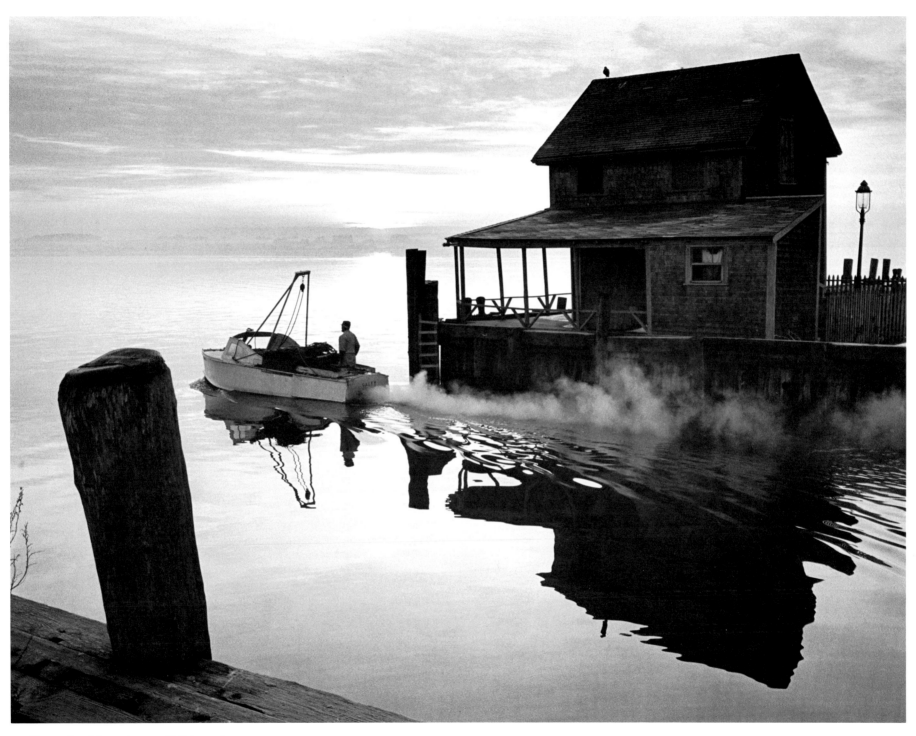

39. *Nantucket, Massachusetts, U.S.A., 1965*

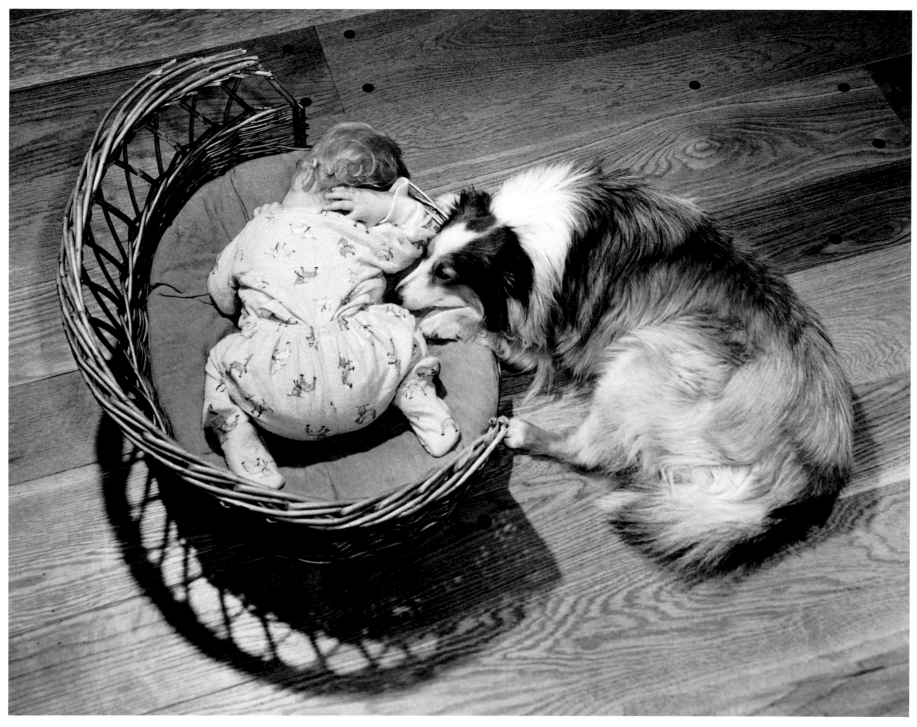

40. *Needham, Massachusetts, U.S.A., 1951*

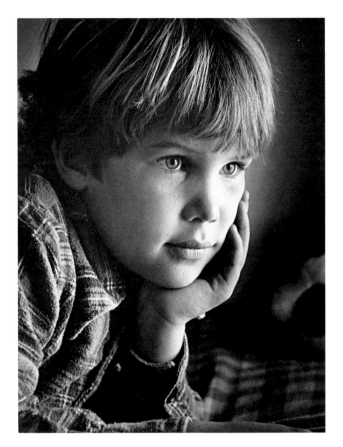

41. *Marblehead, Massachusetts, U.S.A., 1977*

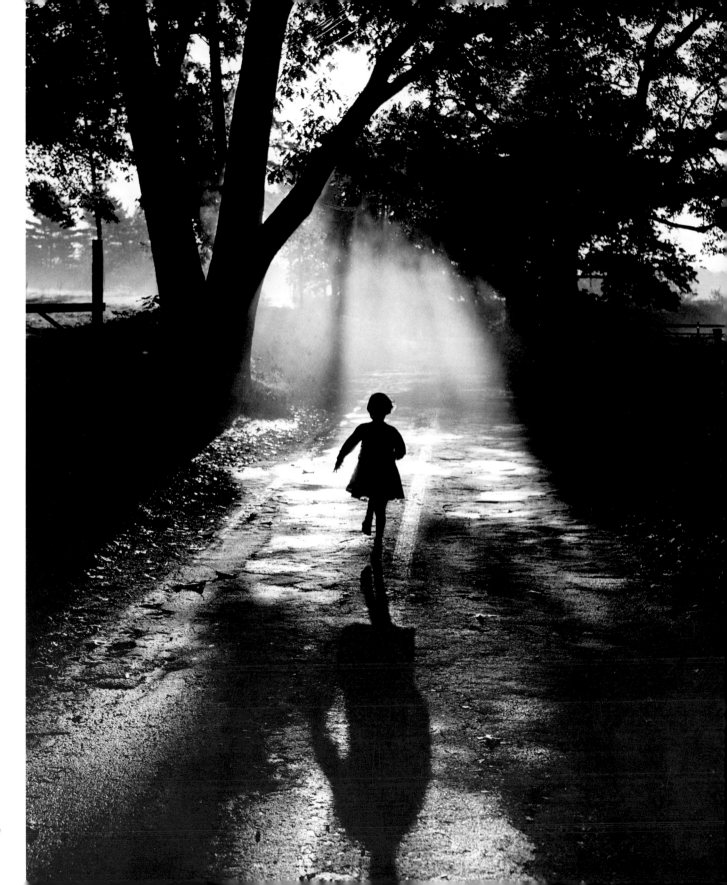

42. *Needham, Massachusetts, U.S.A., 1959*

The earth is the Lord's, and the fulness thereof;

the world, and they that dwell therein.

PSALMS 24:1

EUROPE

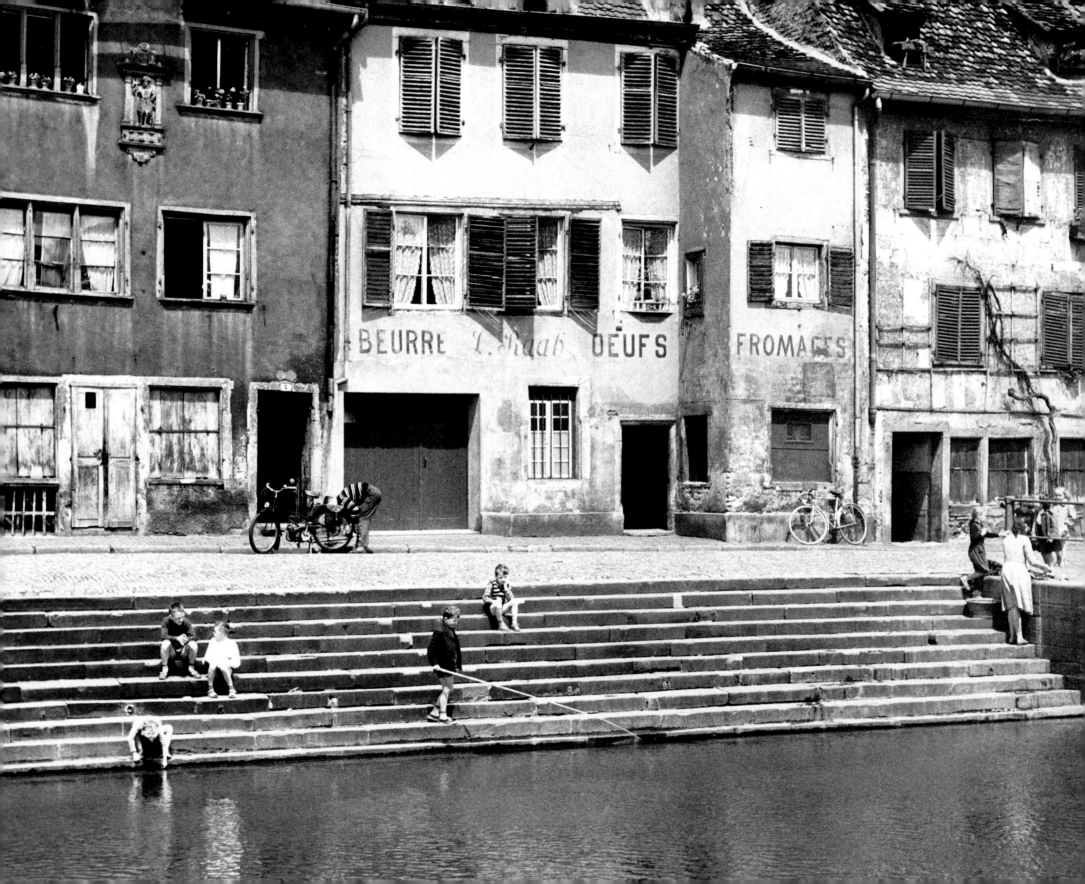

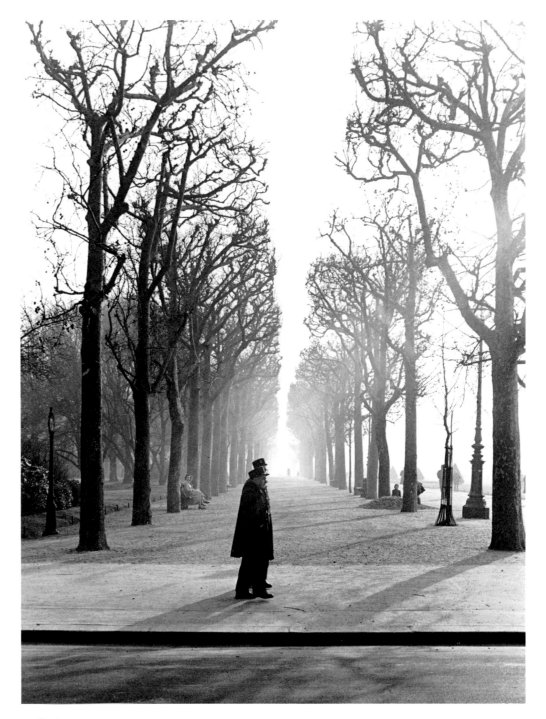

44. *Paris, 1959*

43. *Strasbourg, France, 1961*

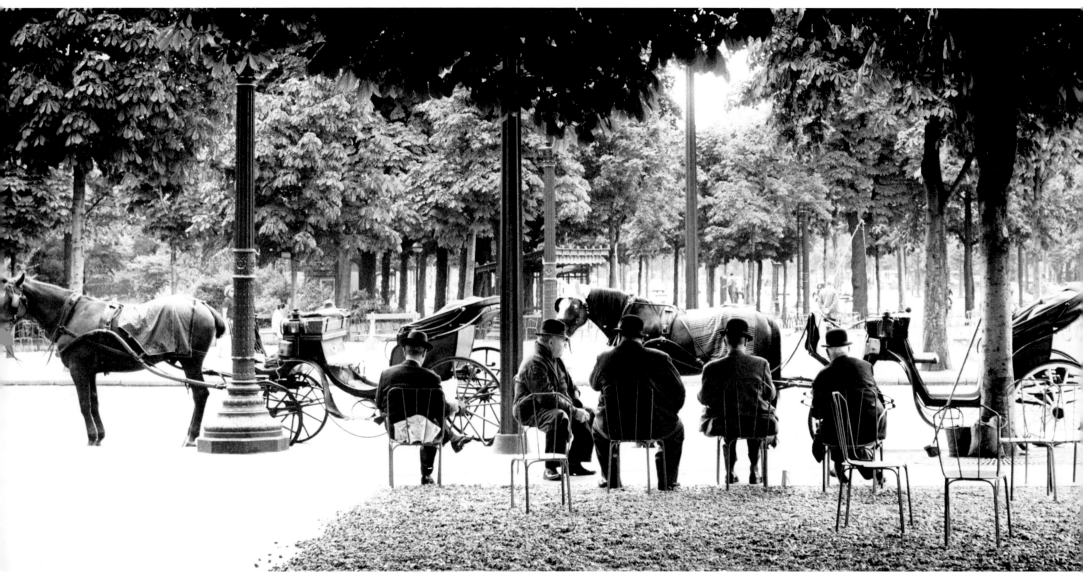

45. *Paris, 1961*

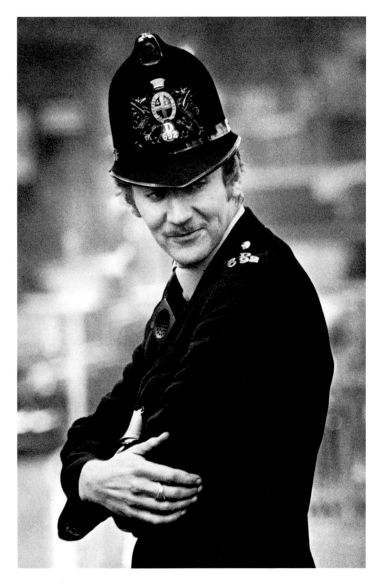

46. London, 1979

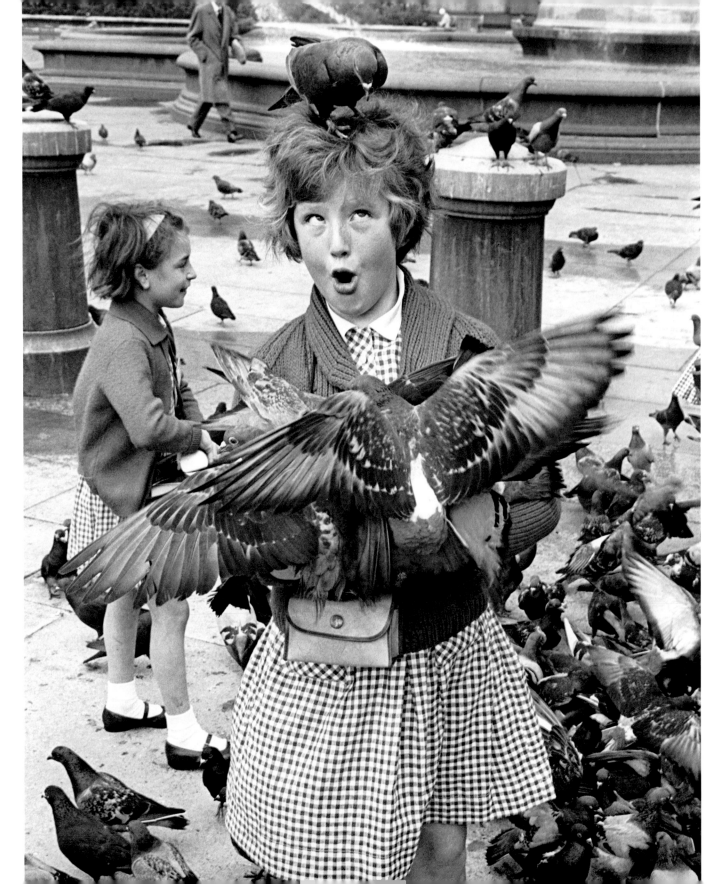

47. London, 1959

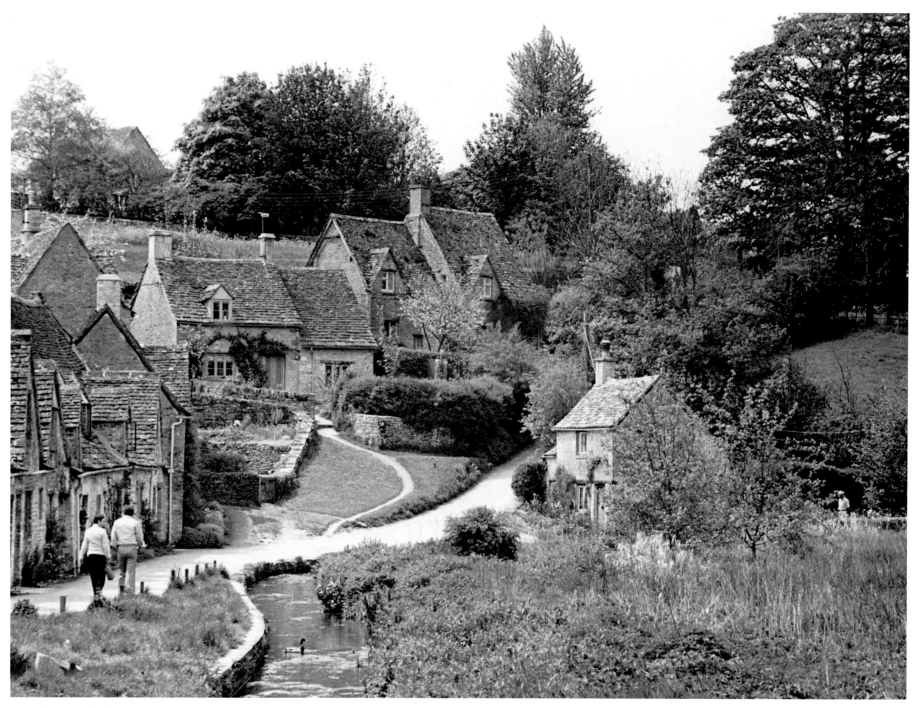

48. *Bibury, England, 1961*

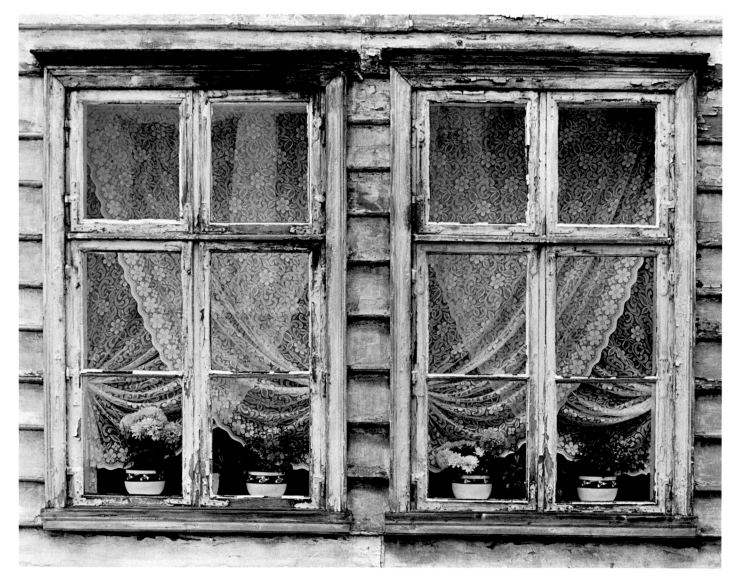

49. Norway, 1974

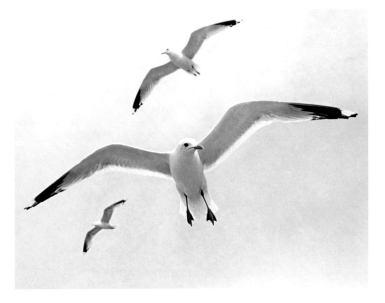

50. *Norway, 1972*

The icebergs of Greenland are strikingly beautiful – especially during the summer months under the soft light of the midnight sun. They look like huge mountains of sculptured ice – yet this is only one ninth of their total size; the rest is below the waterline.

Once on their way in the open ocean, icebergs melt into fantastic shapes, split, fall apart, and finally dissolve, becoming one with the sea. As we cautiously approached one in a small boat, we felt the cold as though a giant refrigerator door had been opened. So near, its size, its exquisite beauty were breathtaking.

Gordon N. Converse

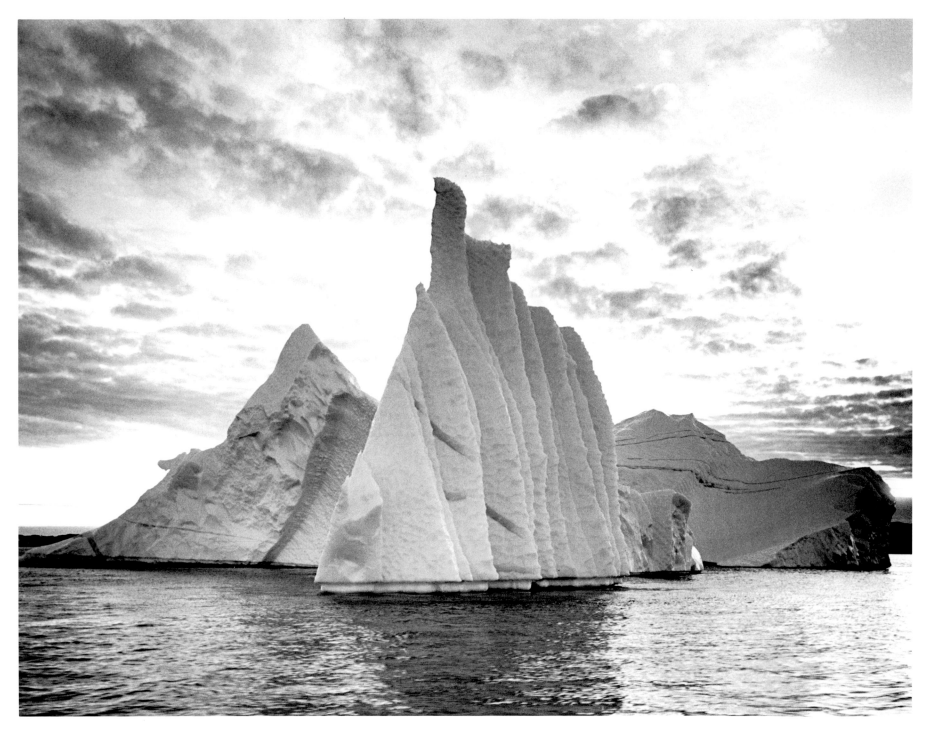

51. *Greenland, 1963*

Athens, the eye of Greece, mother of arts
And eloquence.

JOHN MILTON (1608-1674)

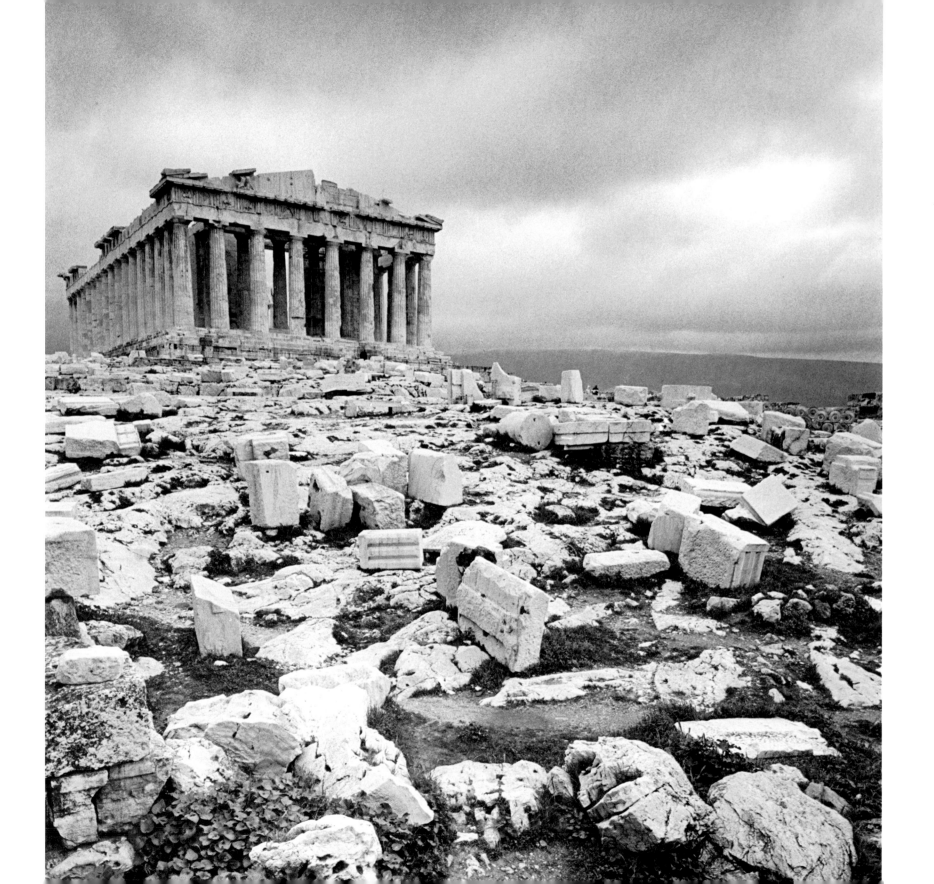

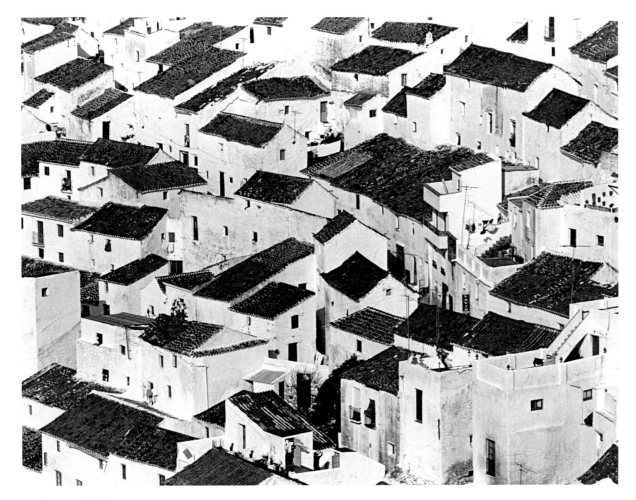

53. *Casares, Spain, 1971*

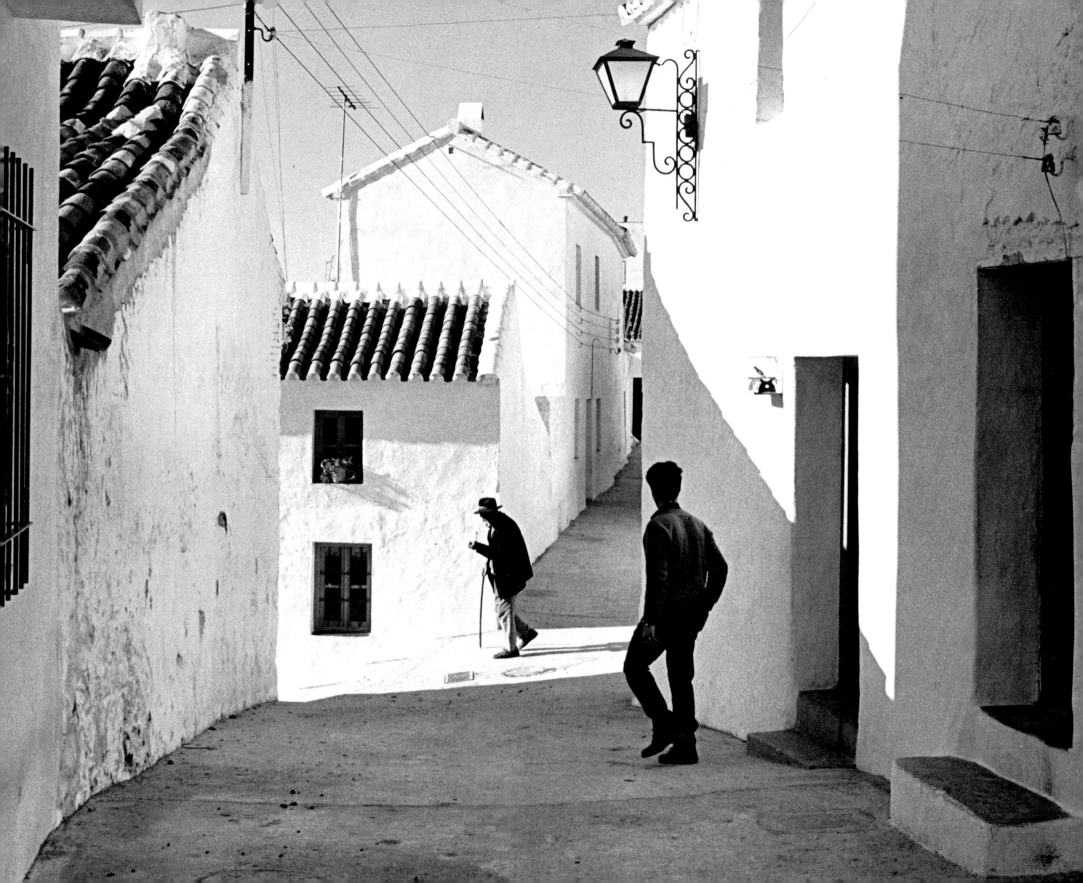

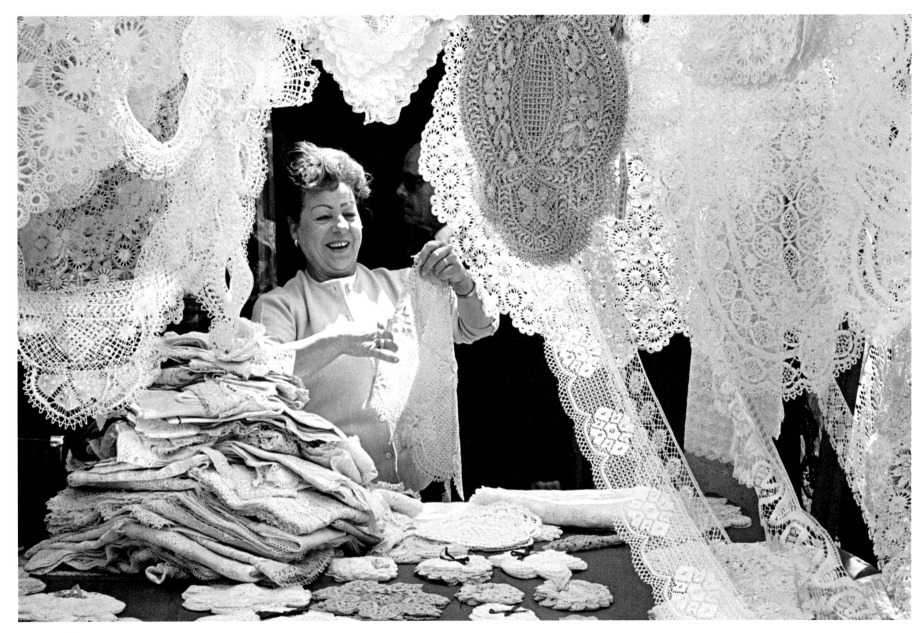

55. *Madrid, 1965*

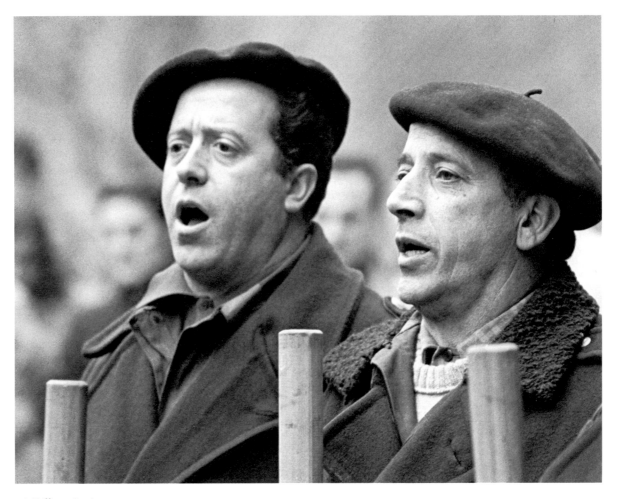

56. *Bilbao, Spain, 1971*

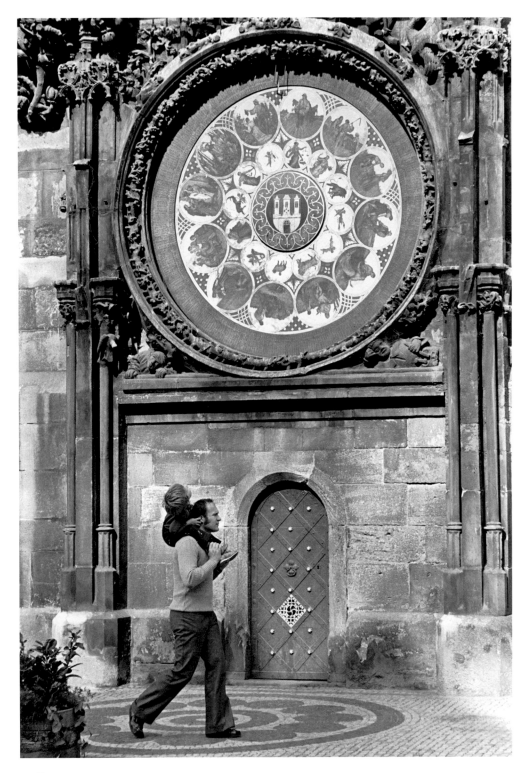

57. *Prague, 1975*

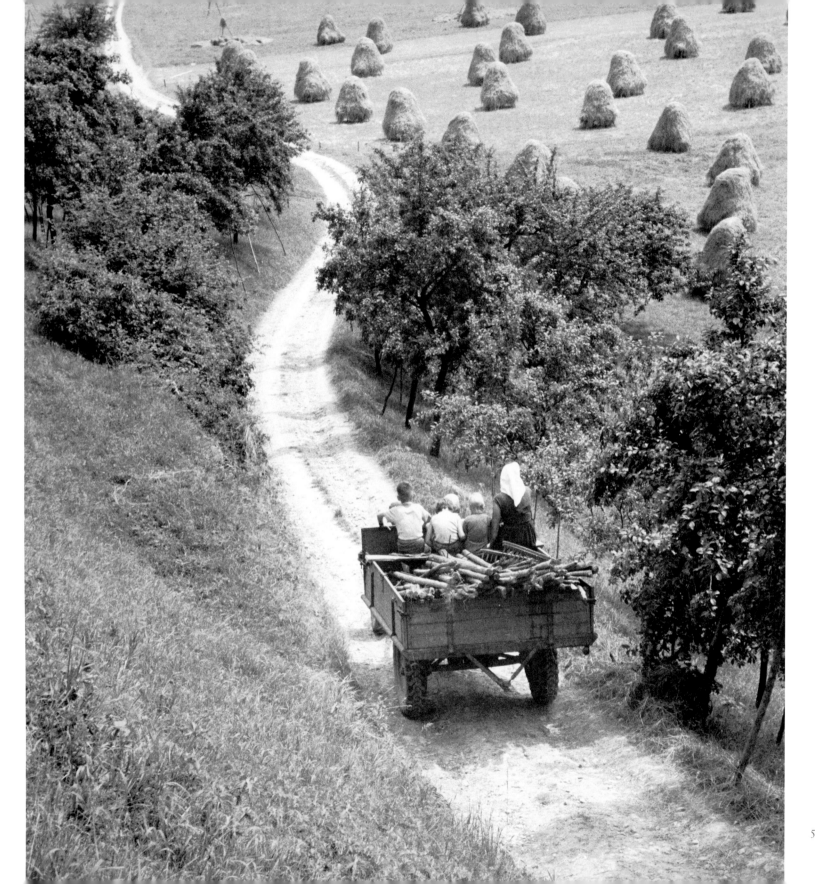

58. Tauber Valley, Germany, 1961

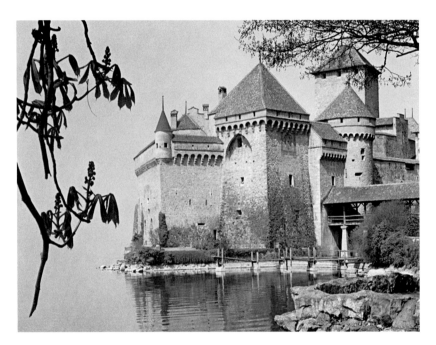

59. *Lake Geneva, Switzerland, 1968*

60. *Switzerland, 1968*

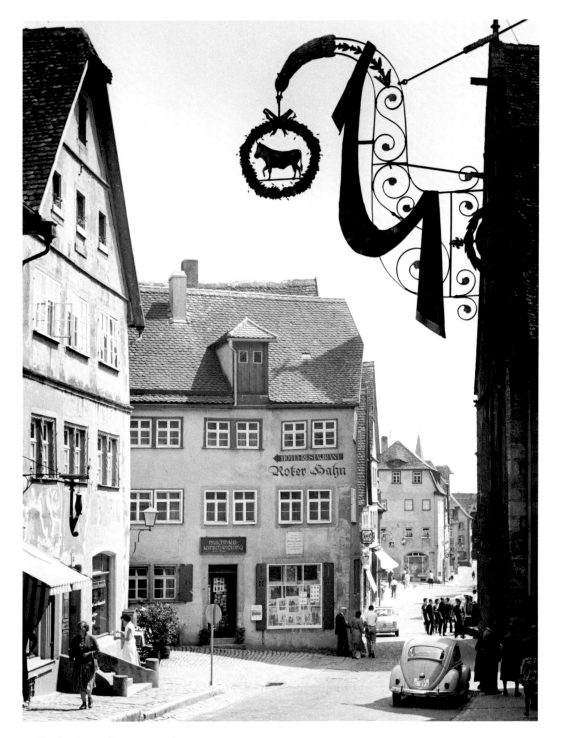

61. Rothenburg, Germany, 1961

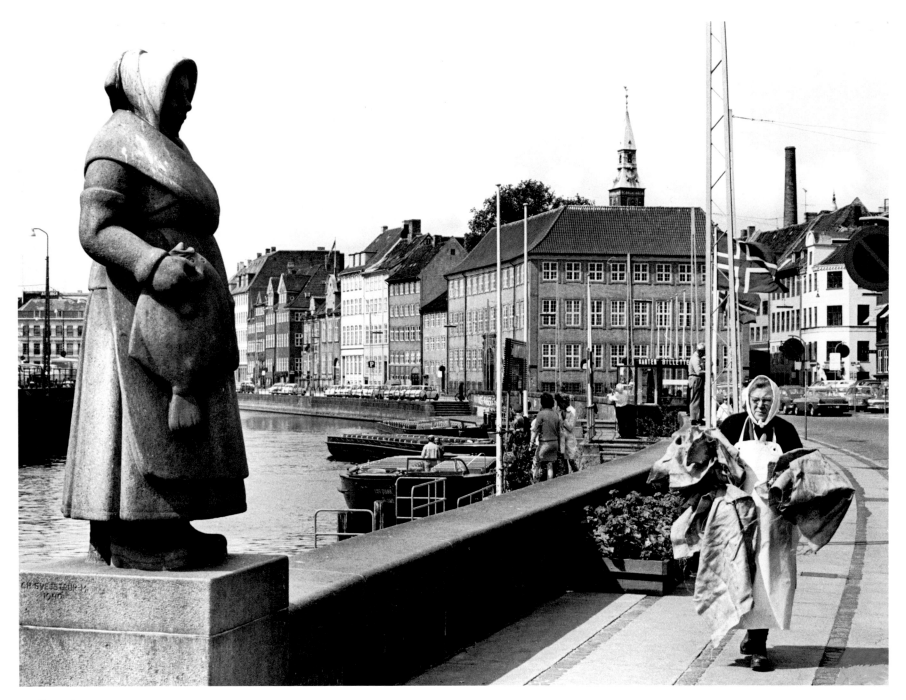

62. *Copenhagen, 1971*

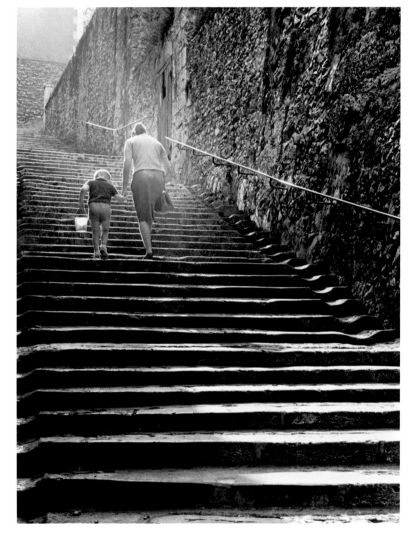

63. *Blois, France, 1961*

64. *Luxembourg City, 1961*

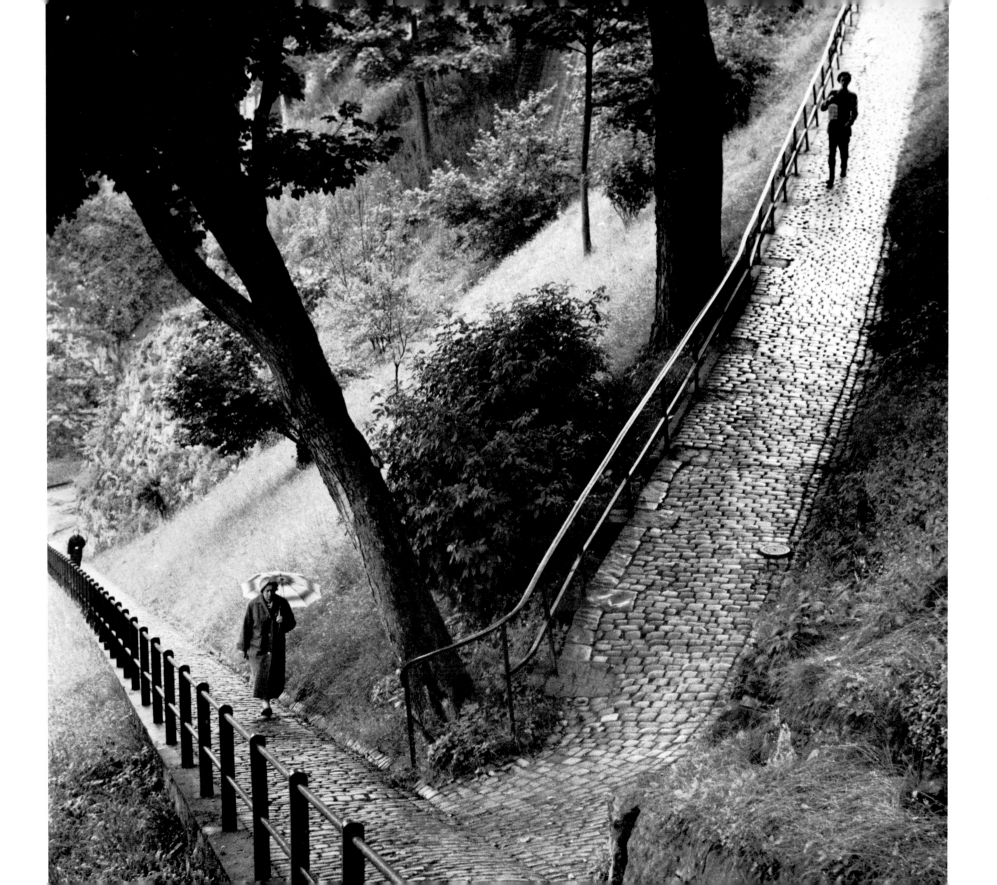

You don't live in a world all alone.

Your brothers are here too.

ALBERT SCHWEITZER (1875-1965)

AFRICA & THE MIDDLE EAST

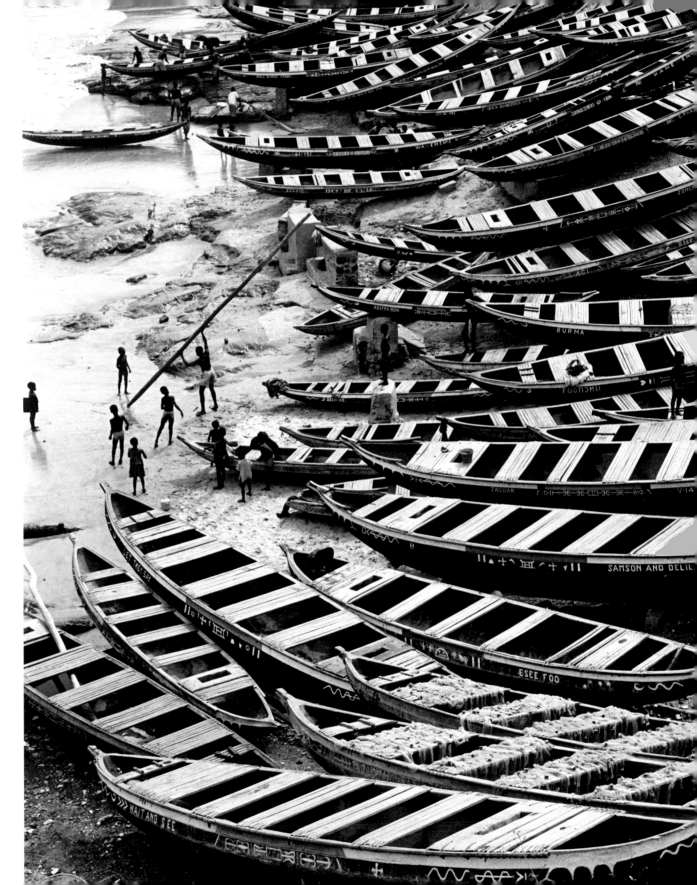

65. *Accra, Ghana, 1959*

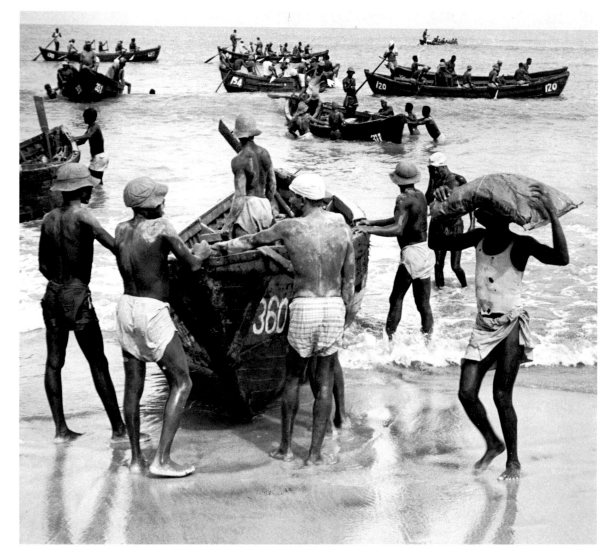

66. *Accra, Ghana,* 1959

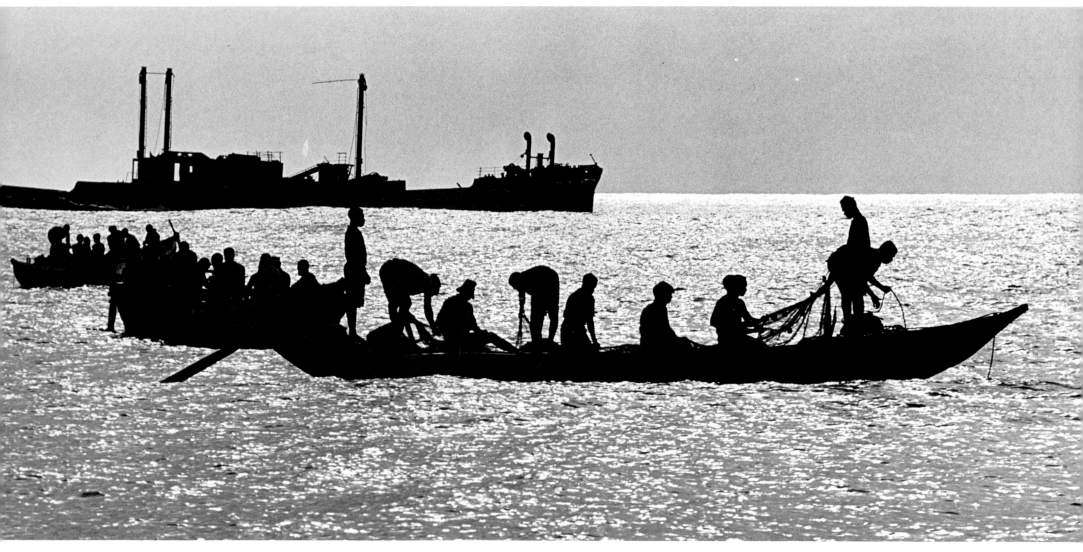

67. *Accra, Ghana, 1959*

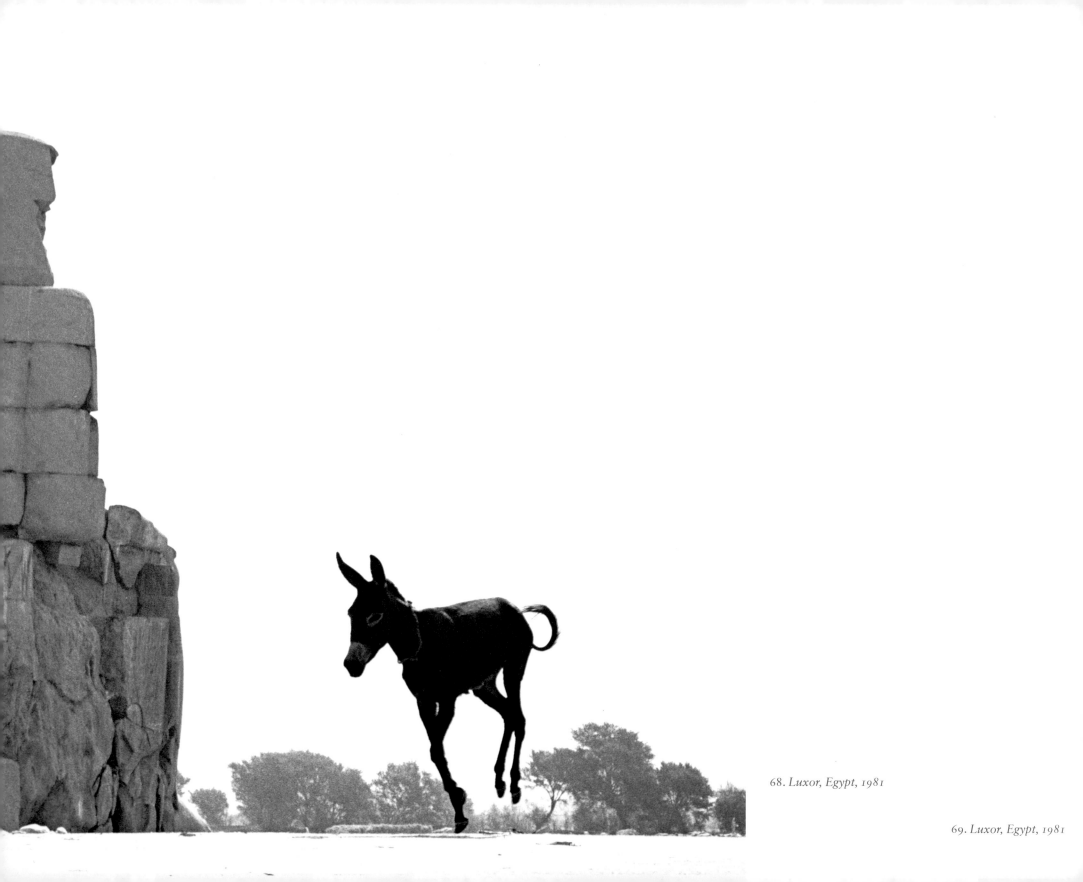

68. Luxor, Egypt, 1981

69. Luxor, Egypt, 1981

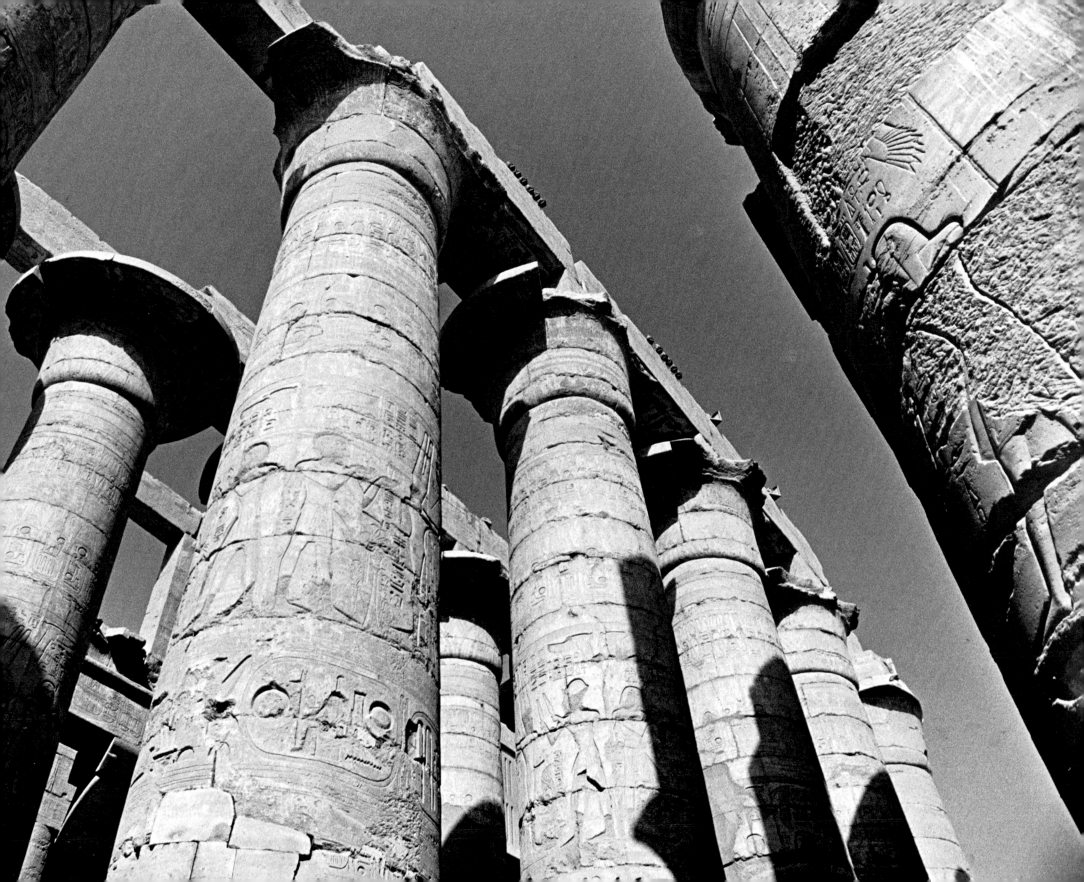

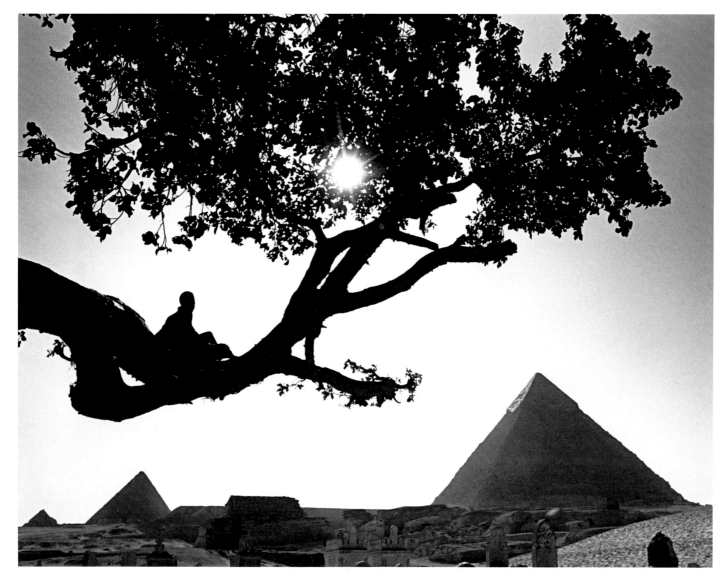

70. *Cairo, 1965*

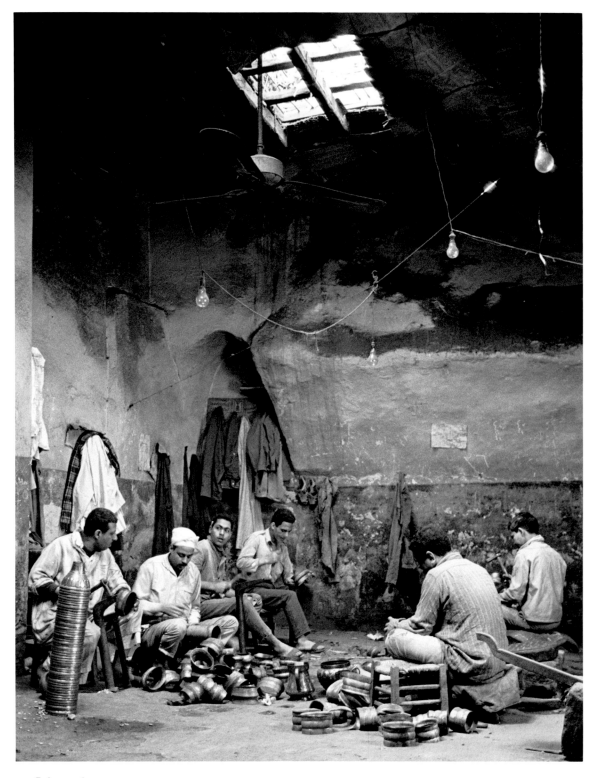

71. *Cairo, 1965*

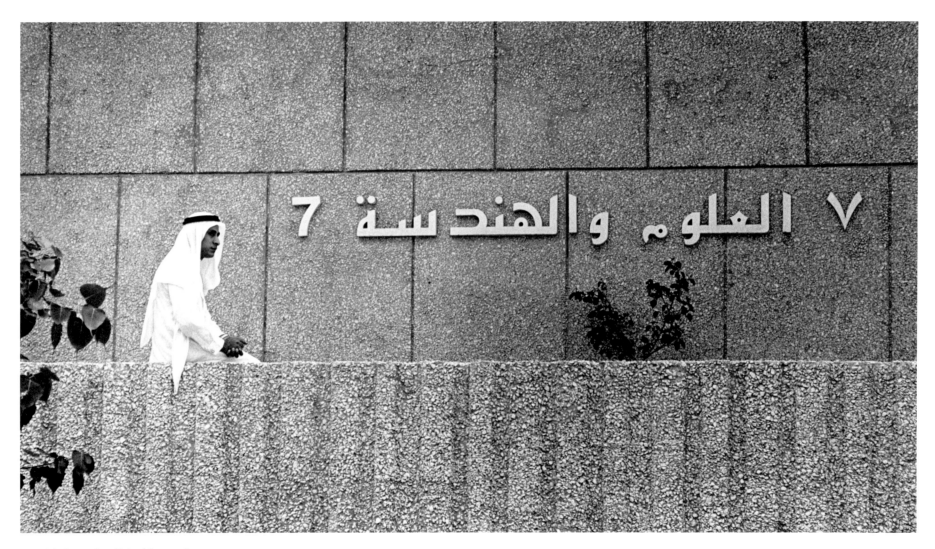

72. Dhahran, Saudi Arabia, 1976

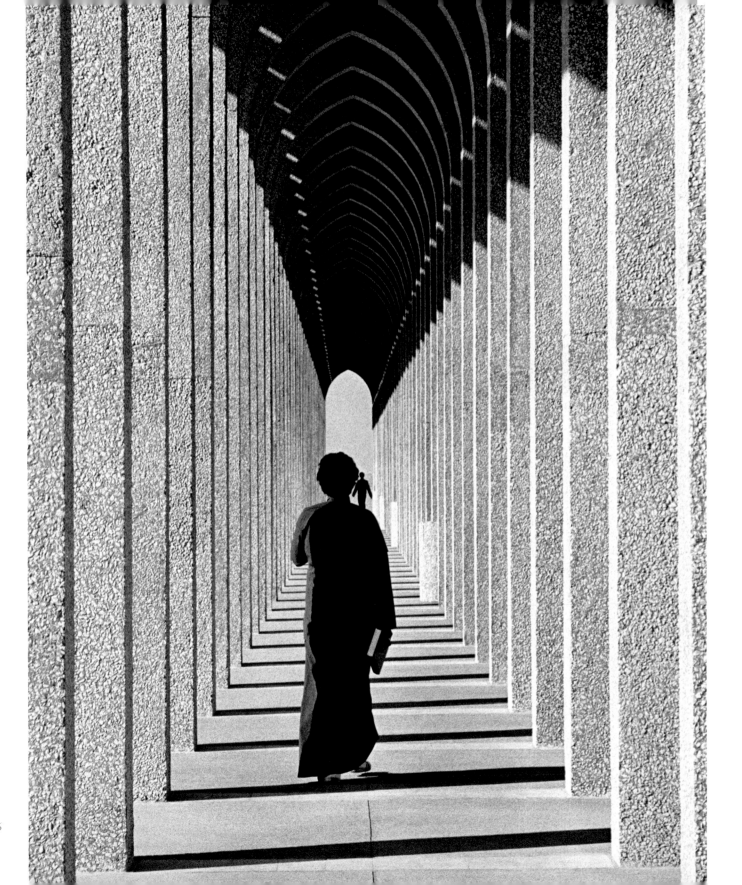

73. *Dhahran, Saudi Arabia, 1976*

74. *Kuwait, 1974*

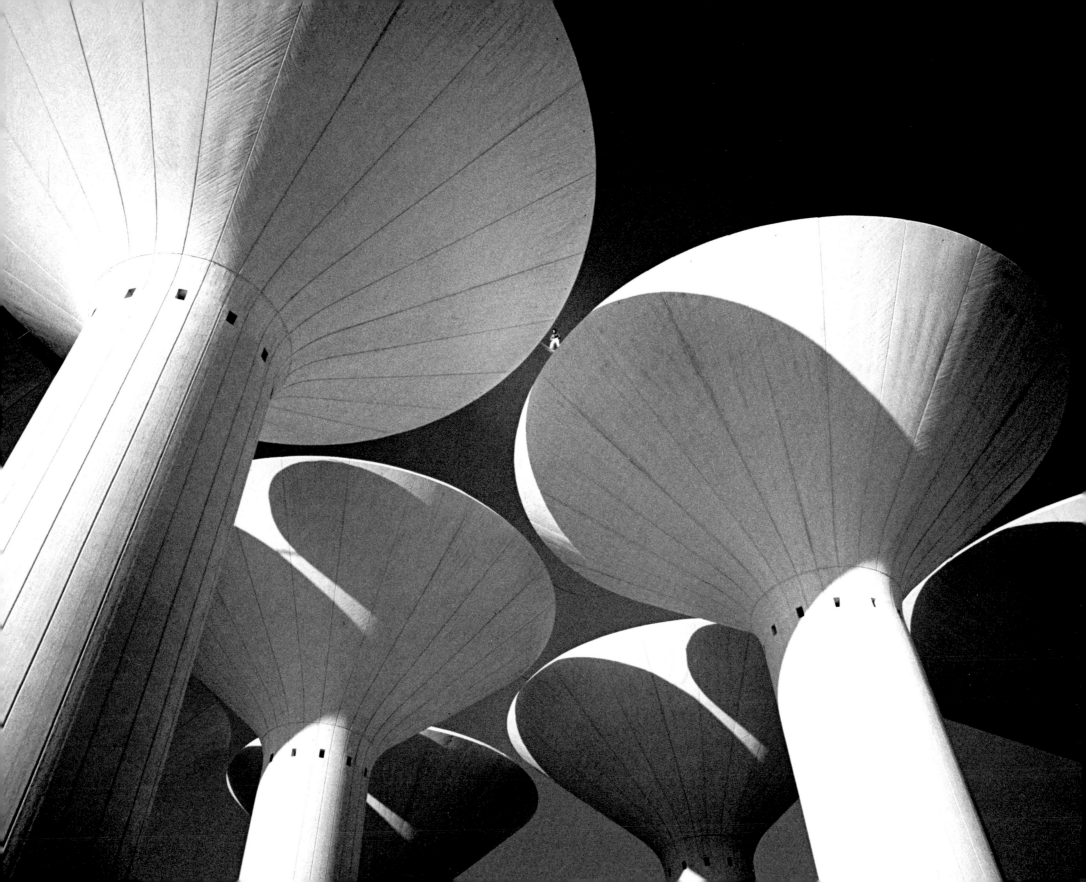

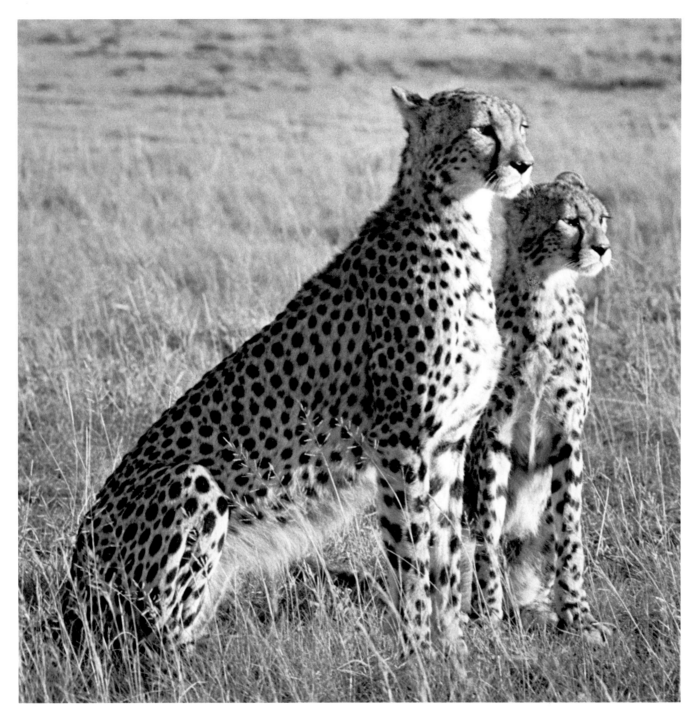

75. Kenya, 1973

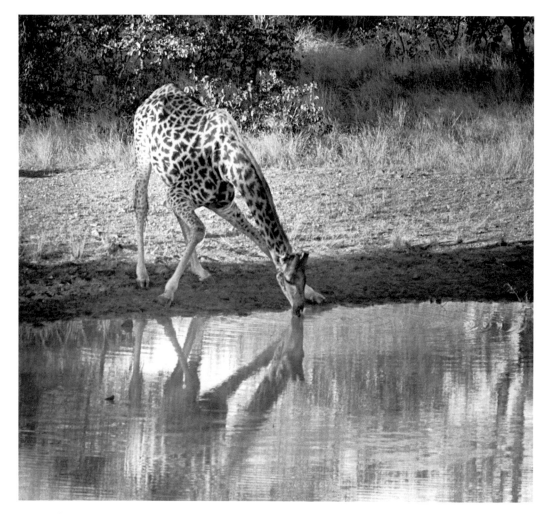

76. *Timbavati Game Reserve, South Africa, 1981*

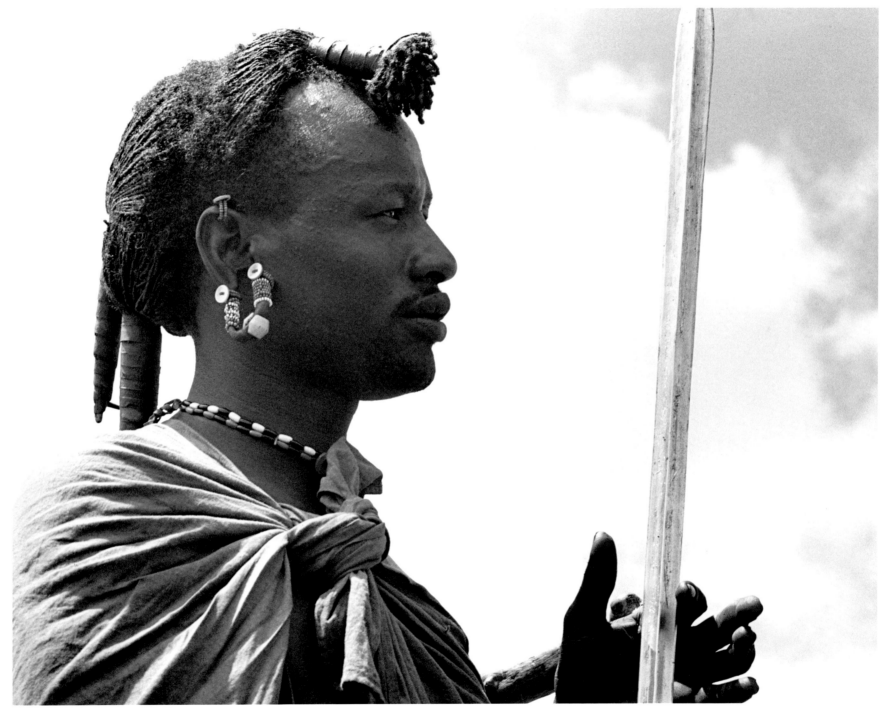

77. *Masailand, Kenya, 1966*

The roads were dusty and hot. Our Land Rover was taking us into the Ngang Hills to visit the proud Masai who cling to their tribal ways. A prolonged draught had forced them deeper into remote areas of Kenya in search of grazing land for their cattle.

We knew we were getting further away from civilization by the abundant wild animals—cheetah, lion, and giraffe. Finally, smoke drifting skyward in the hills told us we had arrived at the encampment. There a stately Masai, with shield and spear, stood guard. He was a magnificent sight!

Other Masai came down from the hills to greet us, many bangled and beaded, and all most friendly. Theirs was a very simple way of life, their diet consisting mostly of blood and milk obtained from their cattle.

As we were about to leave, one of them invited us to stay and take meat with him. We believed it was his way of telling us that he, too, was now a meat eater. Two women, we noticed, were roasting a big chunk of meat over an open pit.

The blackened meat was cut into small pieces and piled into a wooden bowl. We sat in a small circle and, like our hosts, we dug in with our fingers. It took most of an hour to empty the bowl. Satisfied and plenty full, we then returned to our ultramodern hotel in Nairobi.

Gordon N. Converse

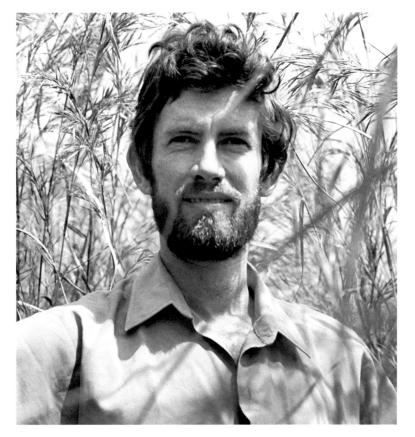

78. *Centenary, Rhodesia (Zimbabwe), 1975*

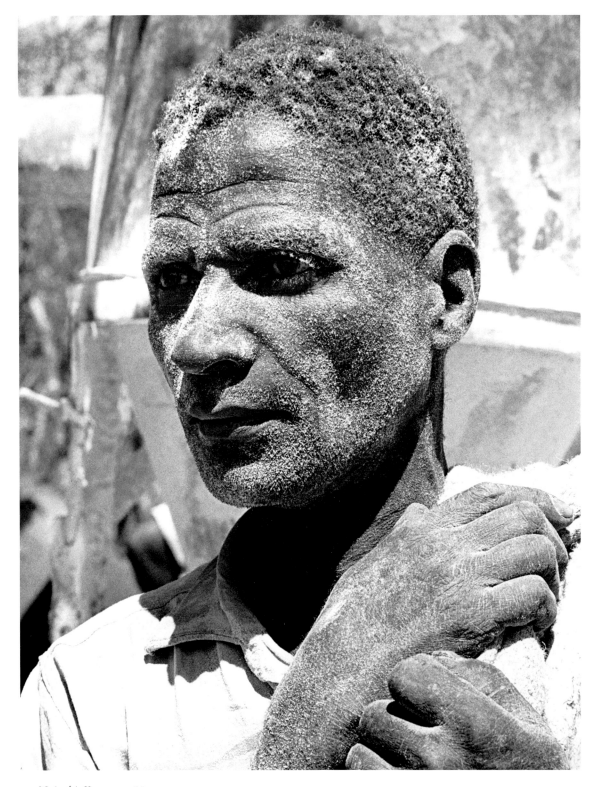

79. *Nairobi, Kenya, 1966*

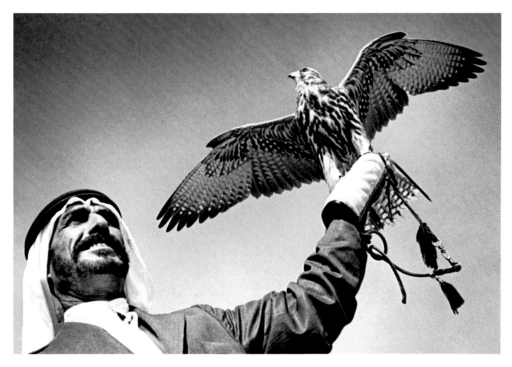

80. *Abu Dhabi, United Arab Emirates, 1974*

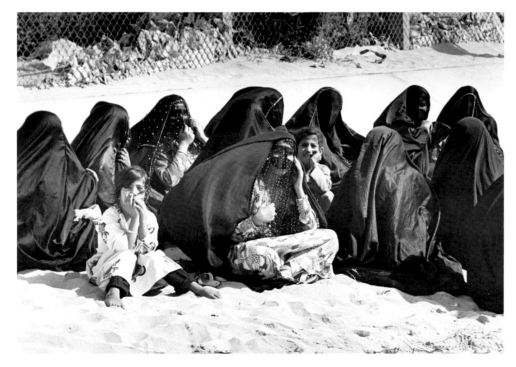

81. *Abu Dhabi, United Arab Emirates, 1974*

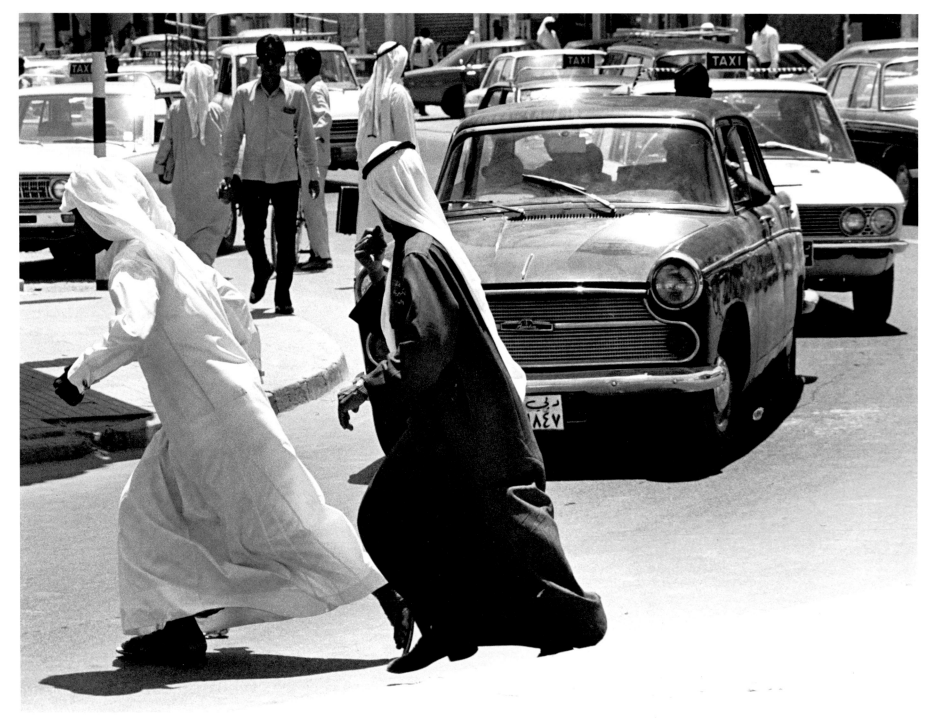

82. Dubai, United Arab Emirates, 1972

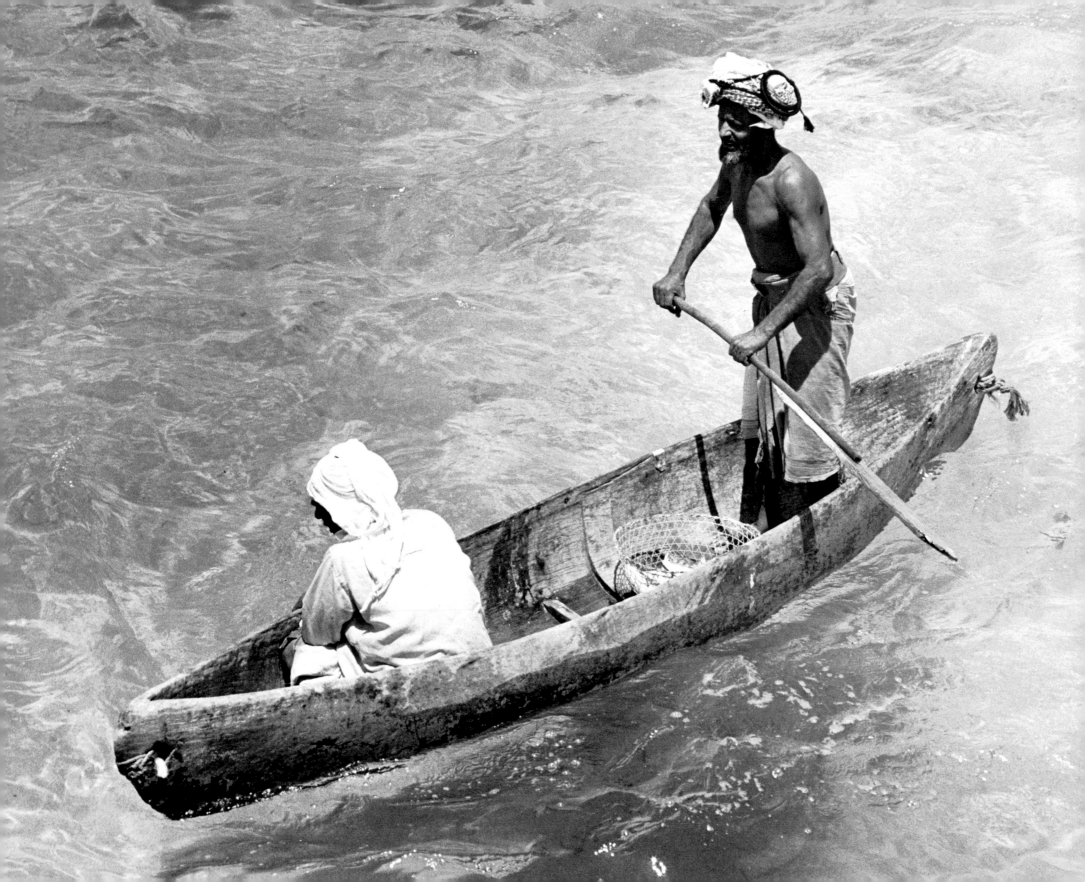

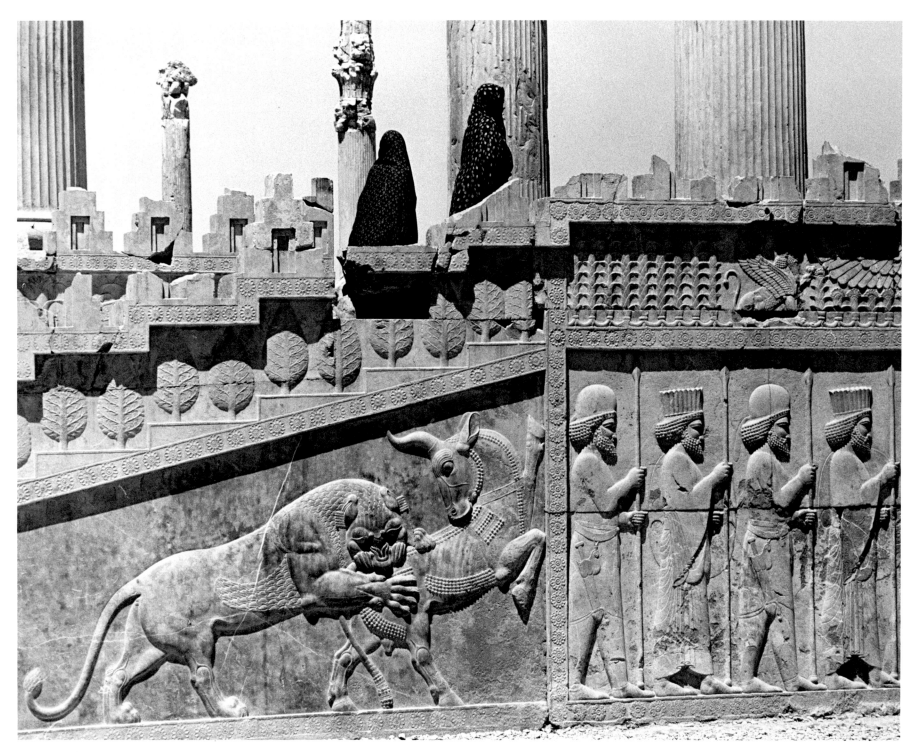

84. Persepolis, Iran, 1974

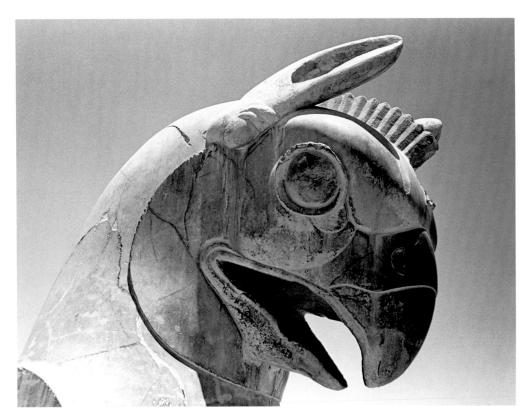

85. *Persepolis, Iran, 1974*

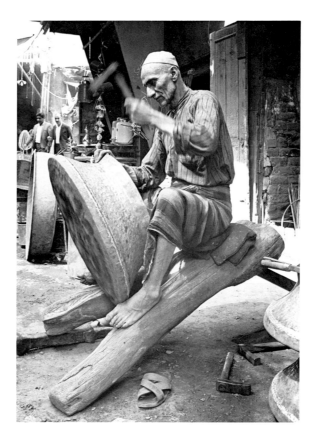

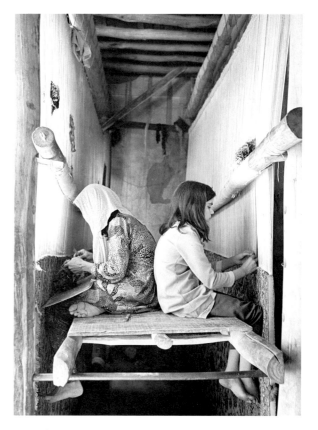

86. Isfahan, Iran, 1974 *87. Baghdad, Iraq, 1965* *88. Isfahan, Iran, 1974*

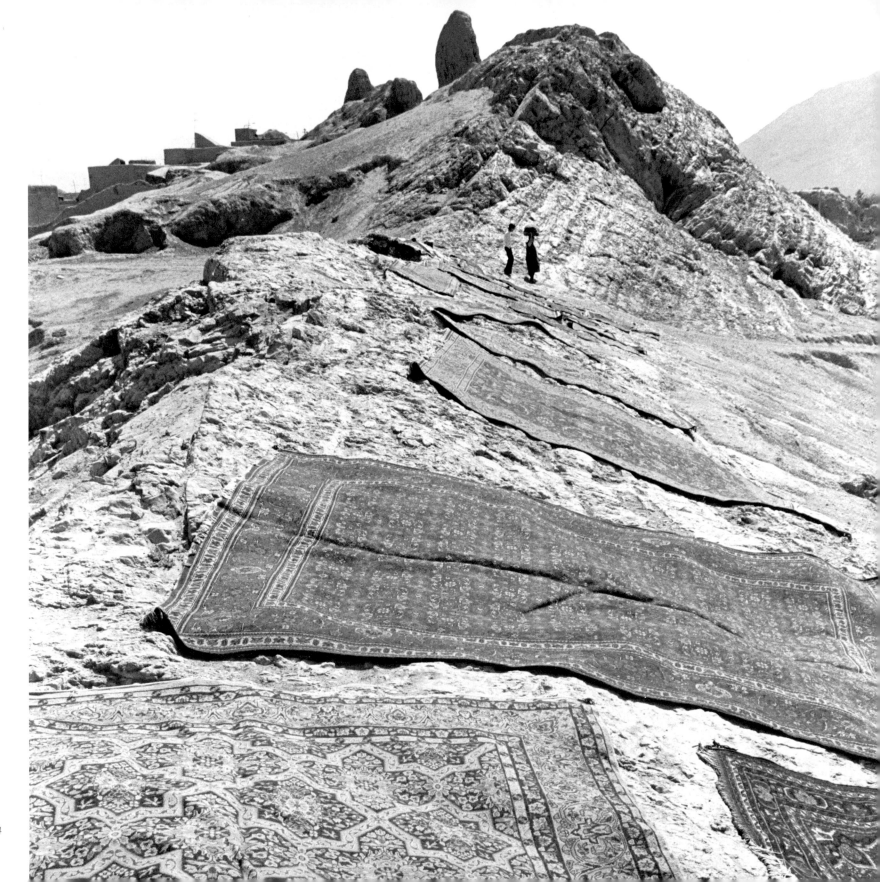

89. Tehran, Iran, 1974

Because of Mideast unrest, Iraqi officials met me at the Baghdad airport and carefully guided my every move. We drove everywhere in a large black limousine, and I saw only what "others" felt I should see.

At the end of my three-day visit I was dropped at the hotel for last-minute packing while the official limousine waited.

There was a soft tap at my door and a bright-eyed Arab boy entered to pick up my bags. He asked, in perfect English, if I had seen the marketplace where his friends and relatives worked.

I told him I hadn't. We both looked at my watch and were on our way.

We left through a side entrance, moving down narrow streets and alleyways. For the first time I was beginning to see, smell, and hear the real heartbeat of Baghdad. More photographs were taken in the next few minutes than during the entire rest of my stay. The culmination came in the area of the silversmiths.

There he sat! His stall was tiny—far too low to stand in. Patiently he worked and waited—waited for someone to slow down, look, and possibly buy.

To others, he remained unnoticed. To me, he was a grand figure right out of biblical times!

Gordon N. Converse

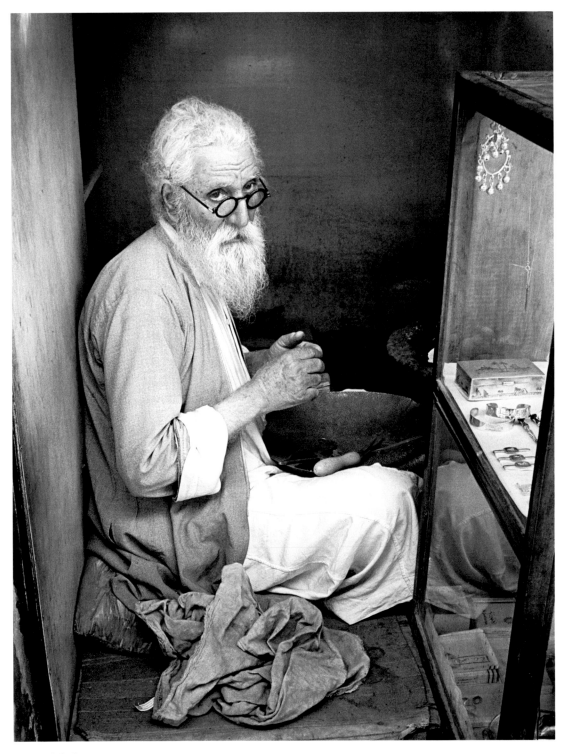

90. *Baghdad, Iraq, 1965*

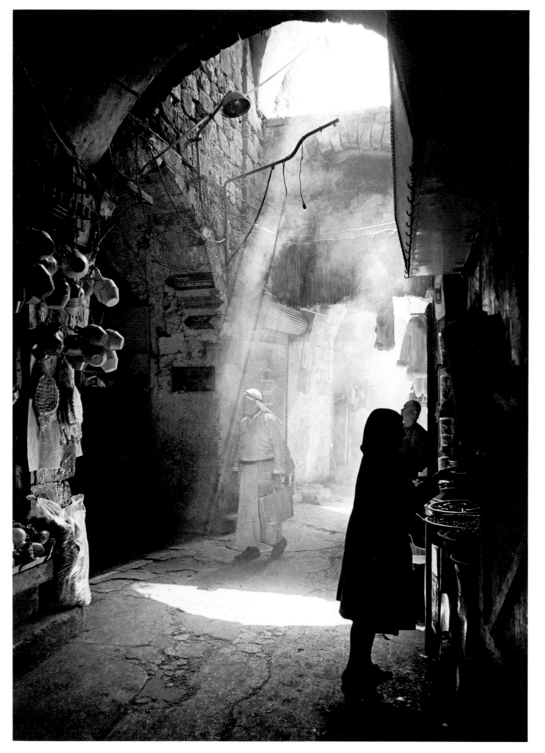

91. *Jerusalem, 1972*

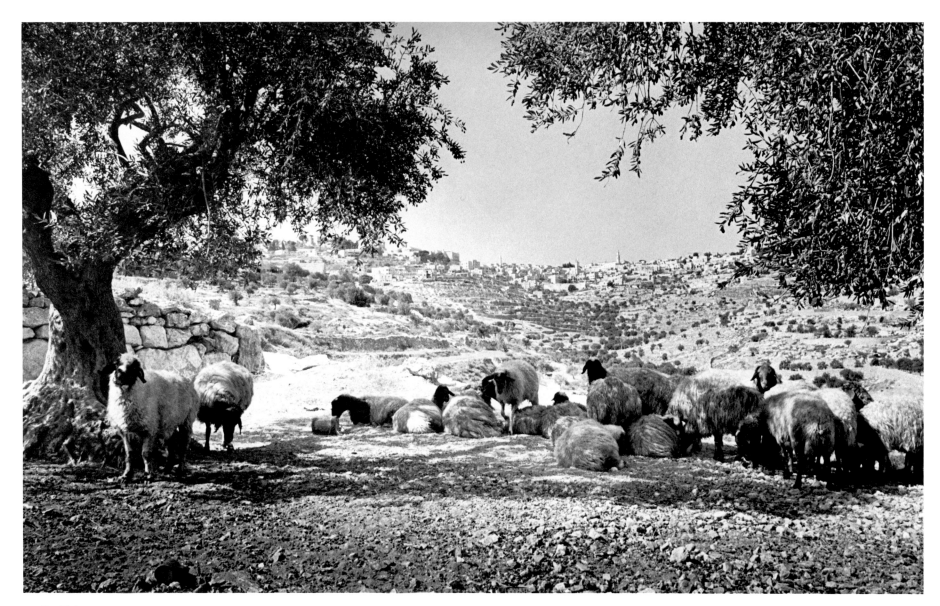

92. Bethlehem, 1972

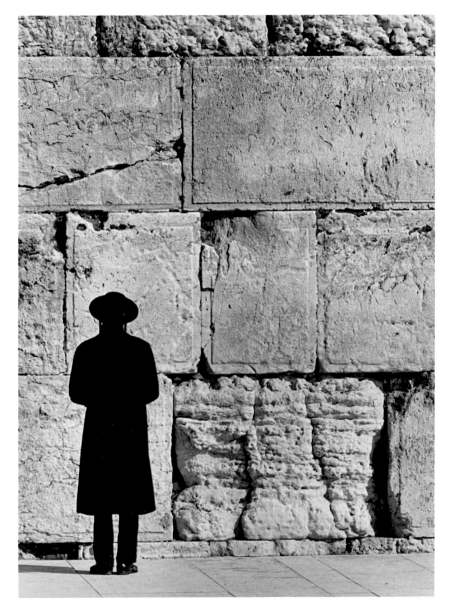

93. *Jerusalem, 1969*

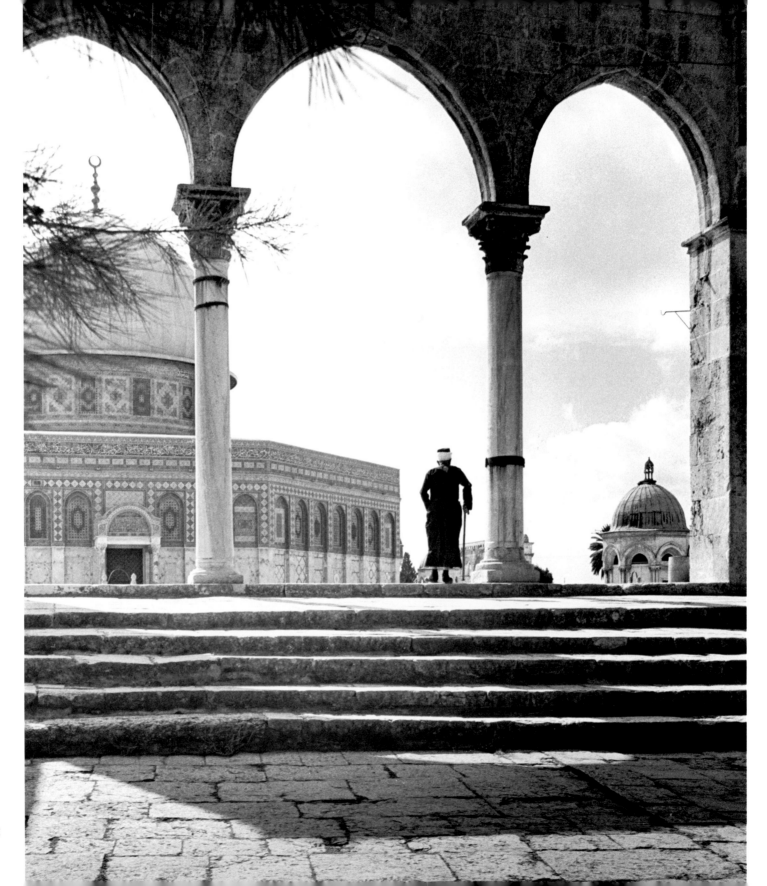

94. Jerusalem, 1976

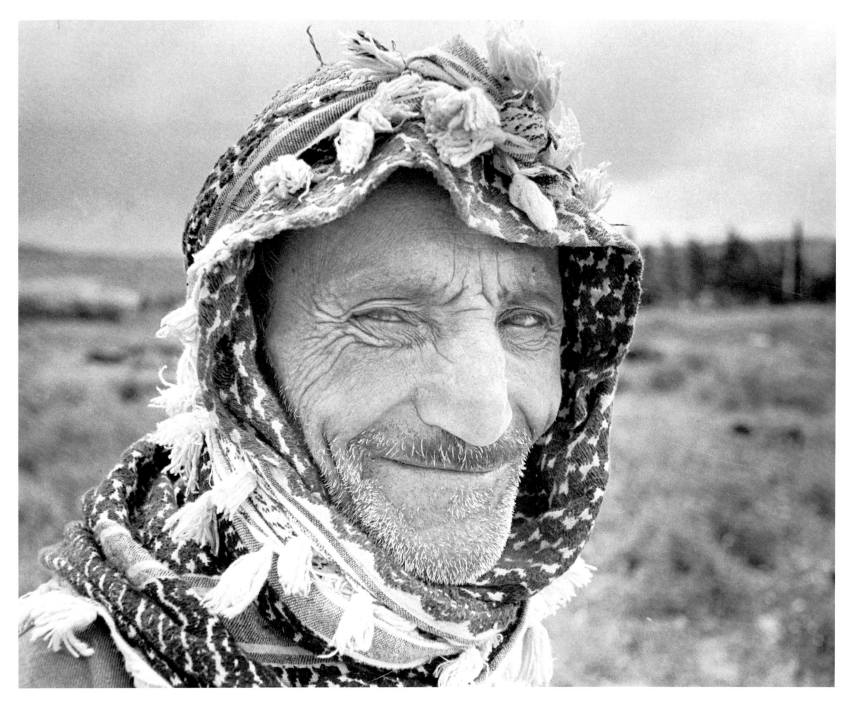

95. *Lebanon, 1974*

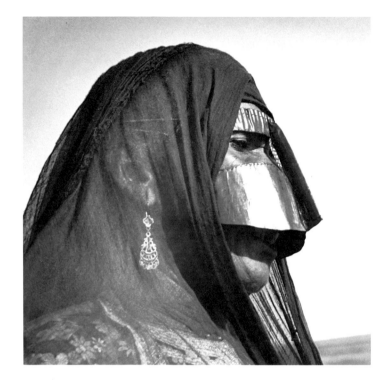

96. *Abu Dhabi, United Arab Emirates, 1974*

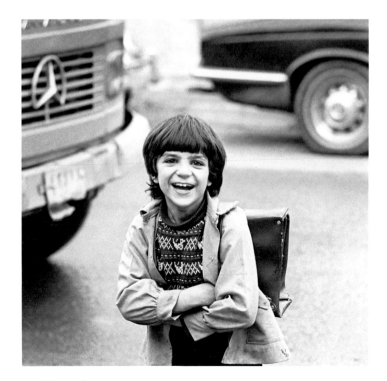

97. *Tehran, Iran, 1974*

98. *Shiraz, Iran, 1974*

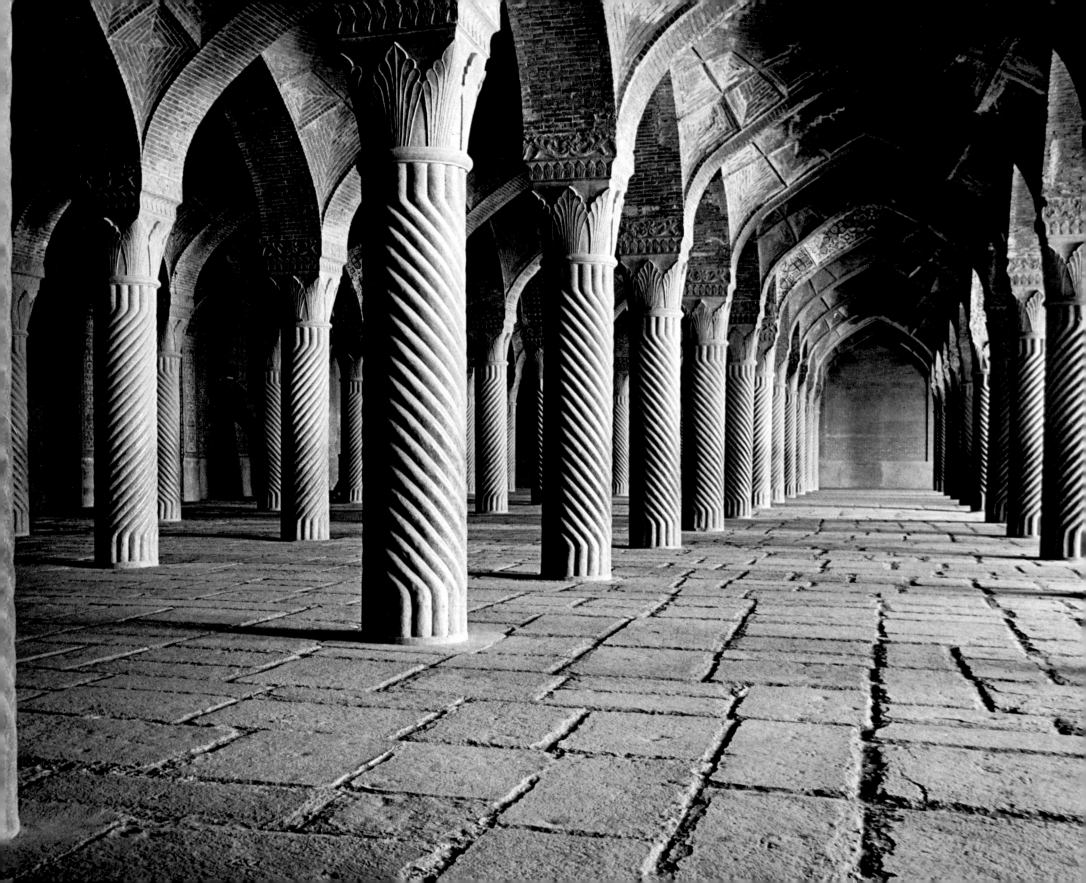

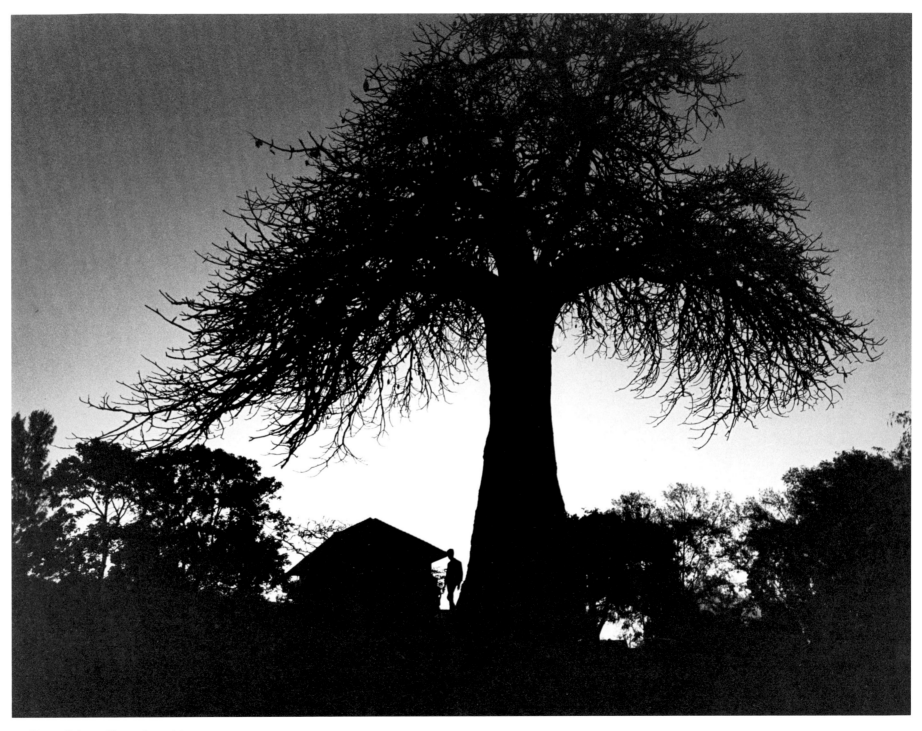

99. Dar es Salaam, Tanzania, 1966

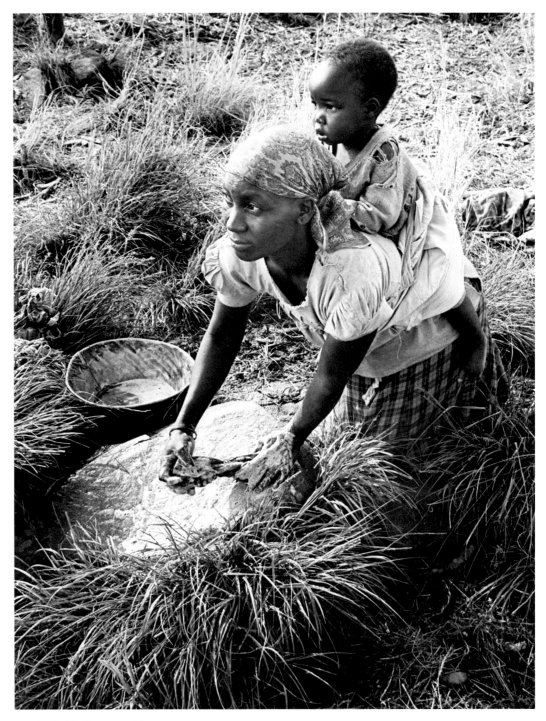

100. *Nairobi, Kenya, 1966*

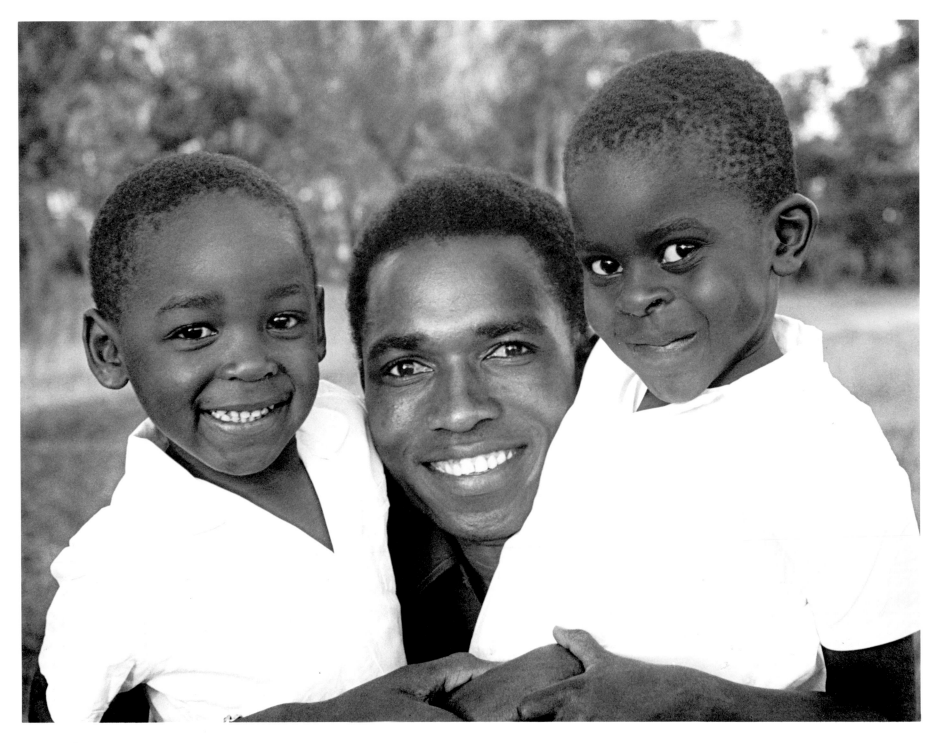

101. *Nairobi, Kenya, 1966*

. . . give me beauty in the inward soul;

and may the outward and inward man be at one.

PLATO (c. 427-c. 347 B.C.)

ASIA & THE PACIFIC

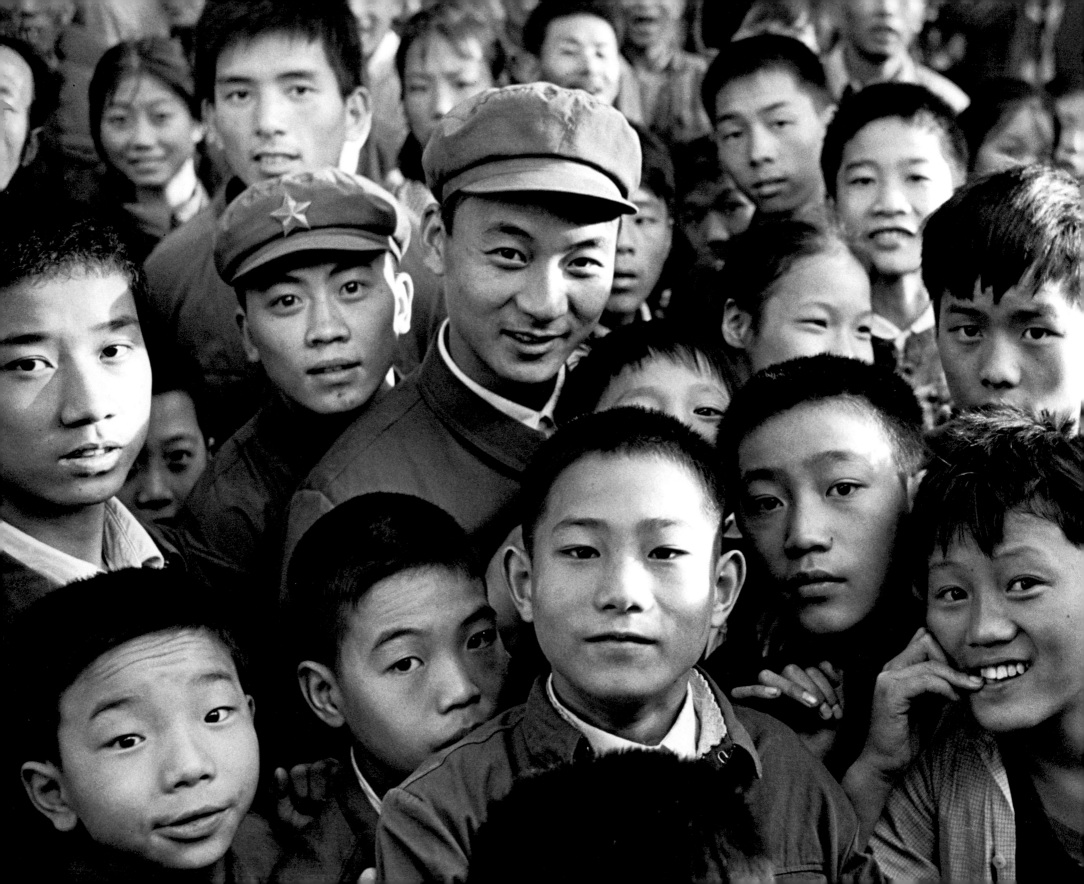

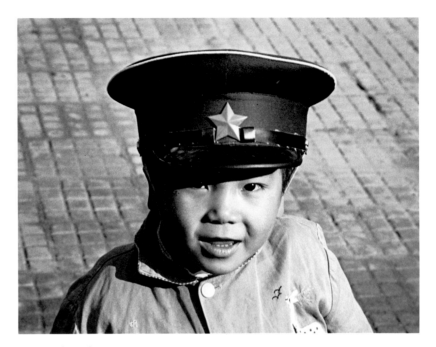

103. *Guilin, China, 1982*

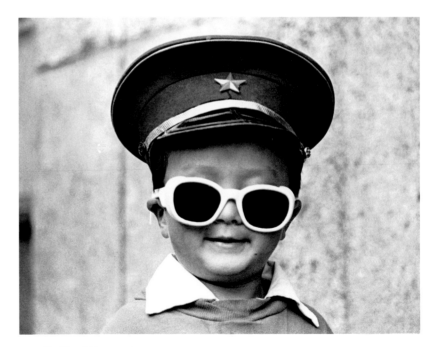

104. *Guilin, China, 1982*

102. *Sian, China, 1980*

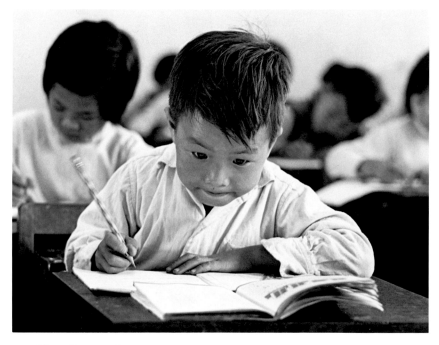

105. *Hong Kong, 1965*

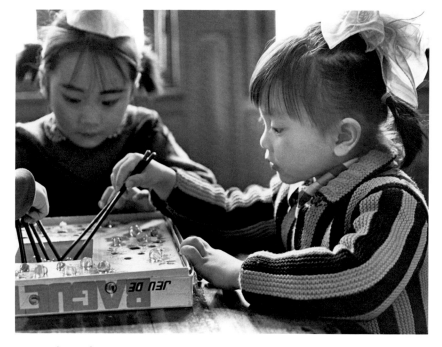

106. *Wuhan, China, 1982*

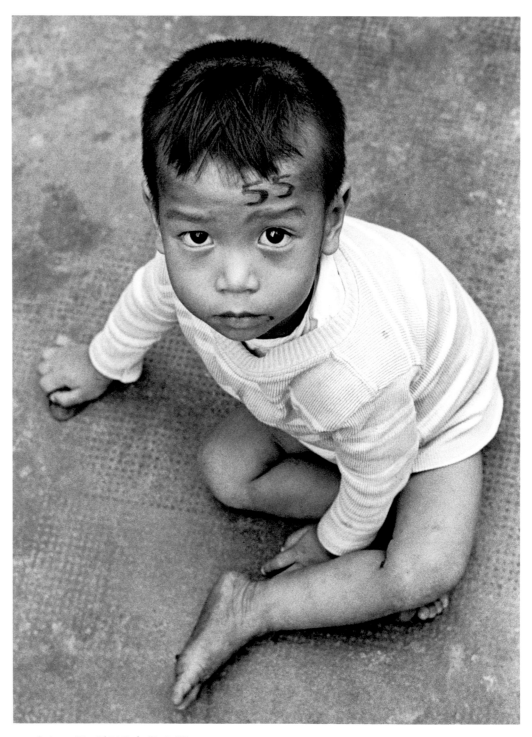

107. *Saigon (Ho Chi Minh City), Vietnam, 1973*

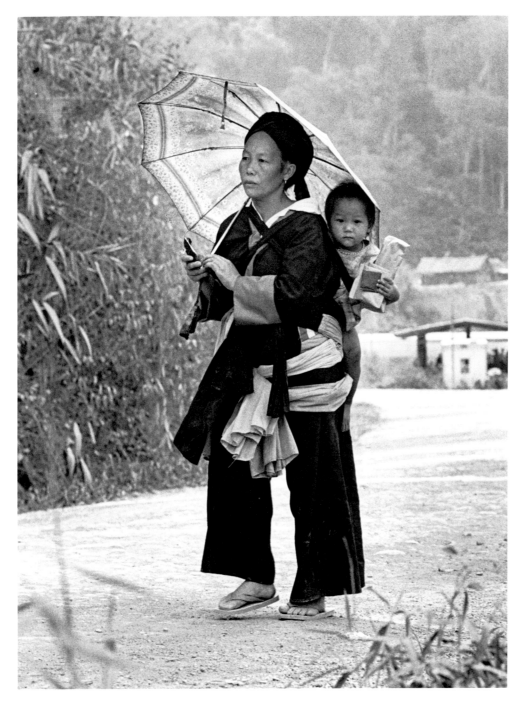

108. Ban Xon, Laos, 1972

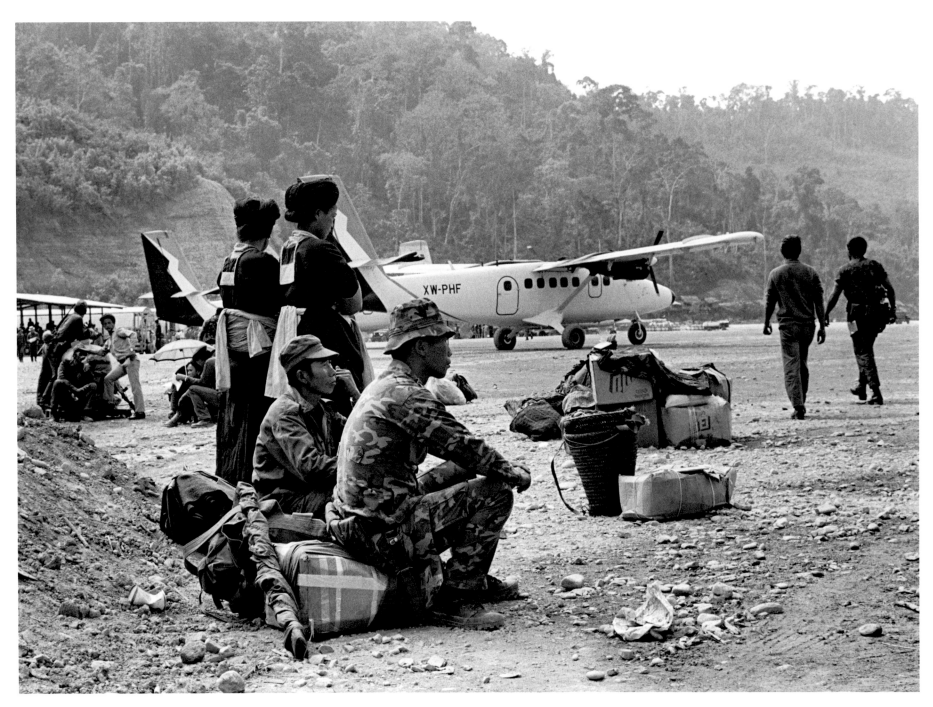

109. *Ban Xon, Laos, 1972*

A bush pilot was willing to fly the reporter and me north and drop
us for a few days in the center of a small Vietnamese town – a
town, we were told, that had been completely surrounded by
Viet Cong guerrillas, but had never been disturbed.

Our stay was strange indeed. We never knew who could be the
enemy. Fighting was taking place in a number of areas around us,
but in the town itself all seemed peaceful.

On a beautiful white sandy beach near the edge of town, I came
across a net mender who appeared completely untouched by
signs of war. As I photographed him serene at work, I found
myself wondering if he might be a peaceful citizen by day and
an active terrorist by night. In Vietnam, one never really knew.

Gordon N. Converse

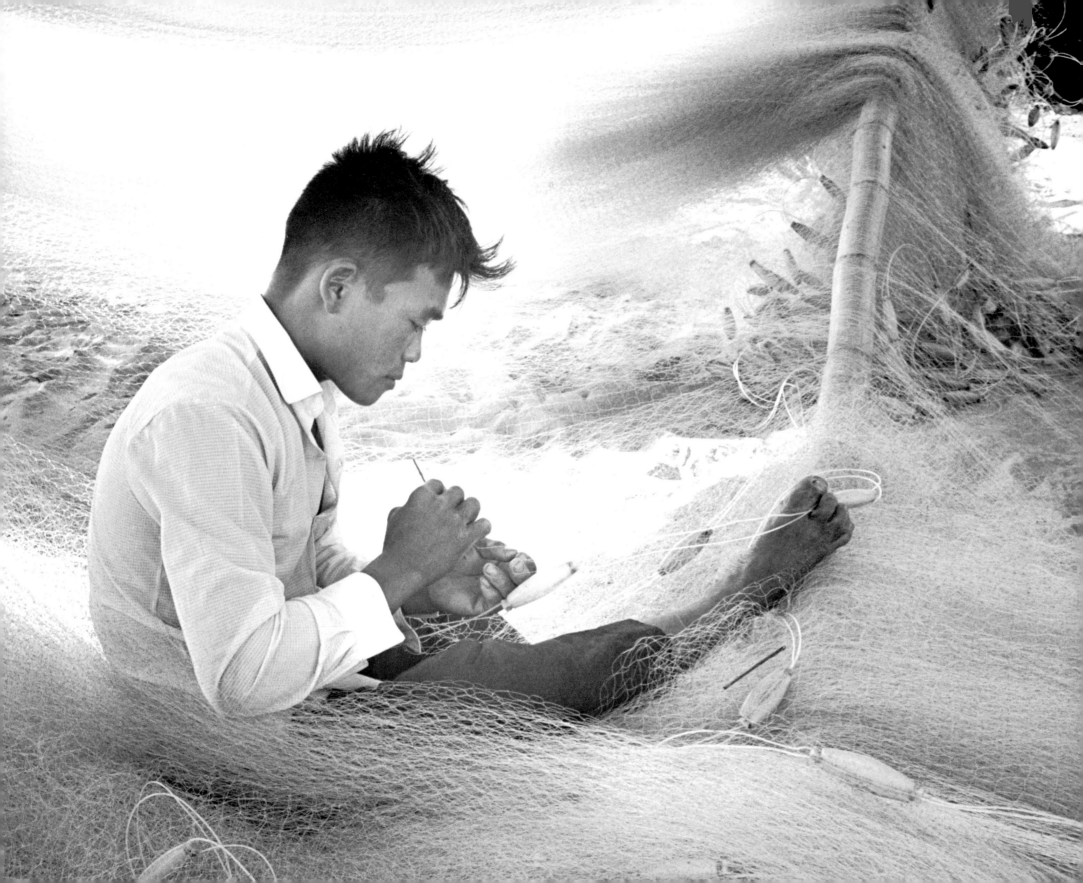

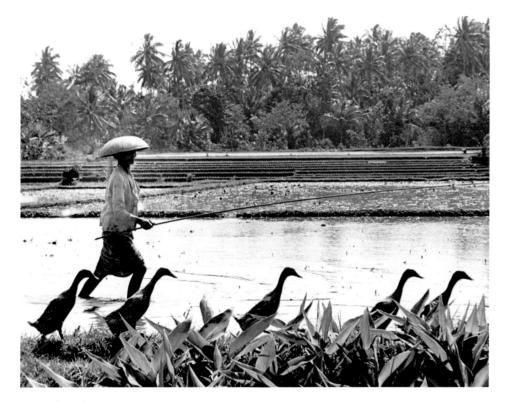

111. *Bali, Indonesia, 1974*

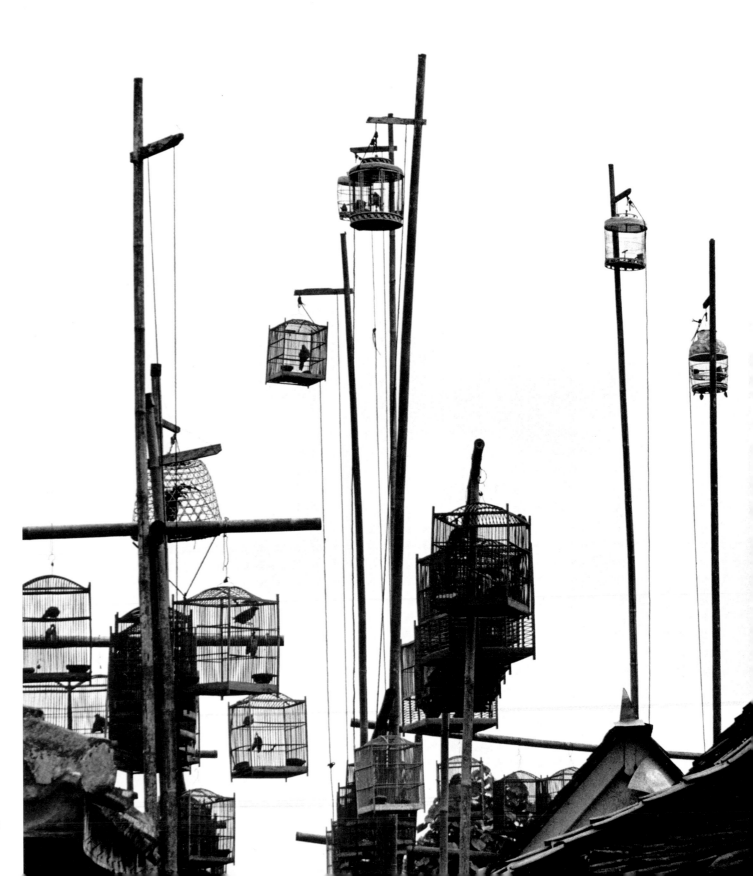

112. *Jogjakarta, Indonesia, 1974*

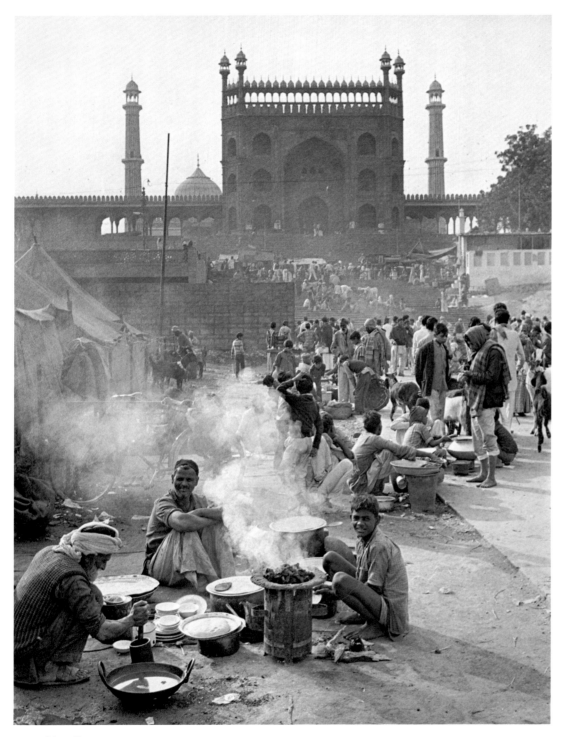

113. *Old Delhi, 1978*

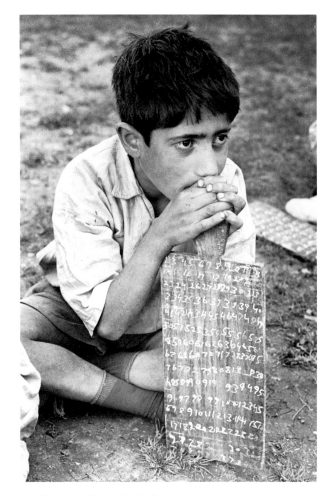

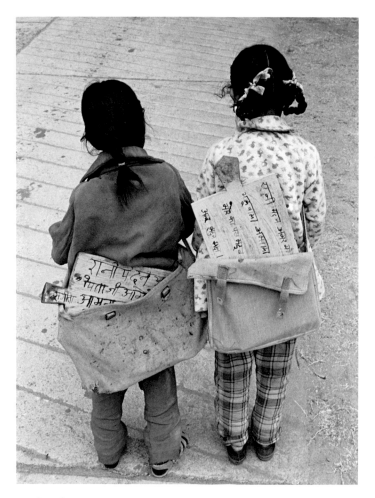

114. *Srinagar, Kashmir, India, 1978*

115. *Bombay, 1972*

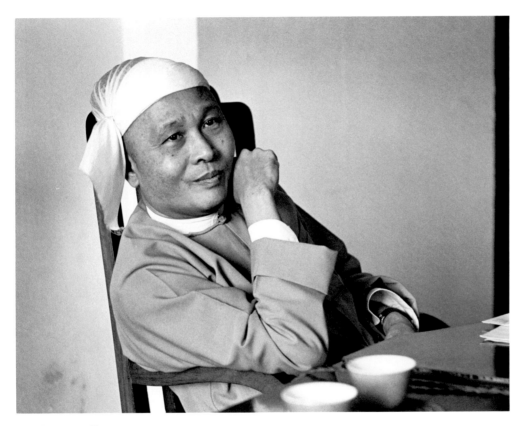

116. Rangoon, Burma, 1959

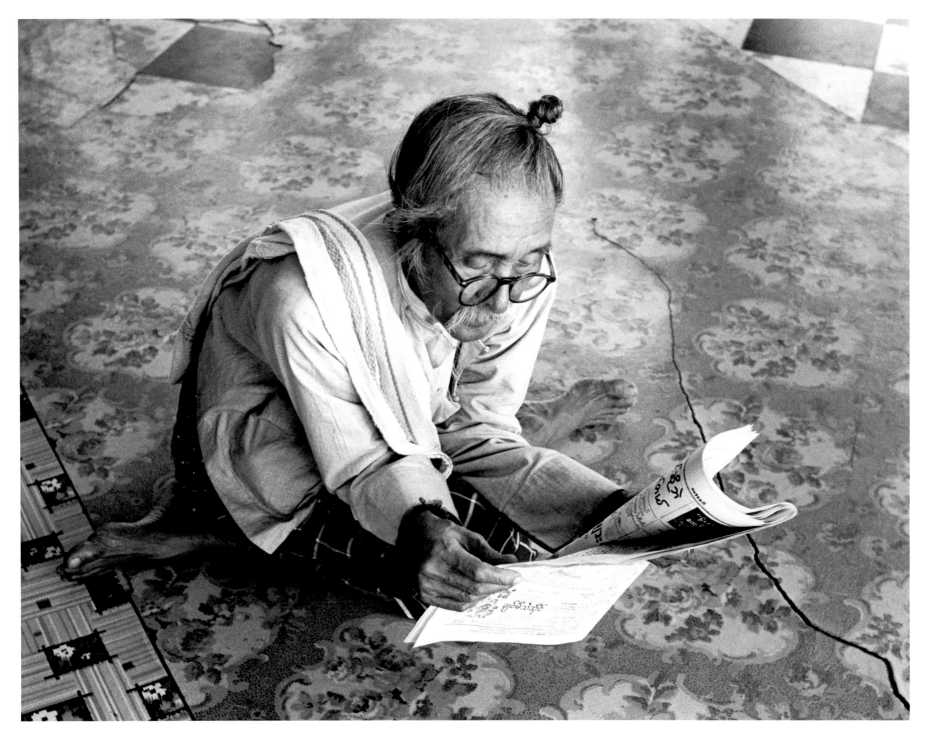

117. Rangoon, Burma, 1958

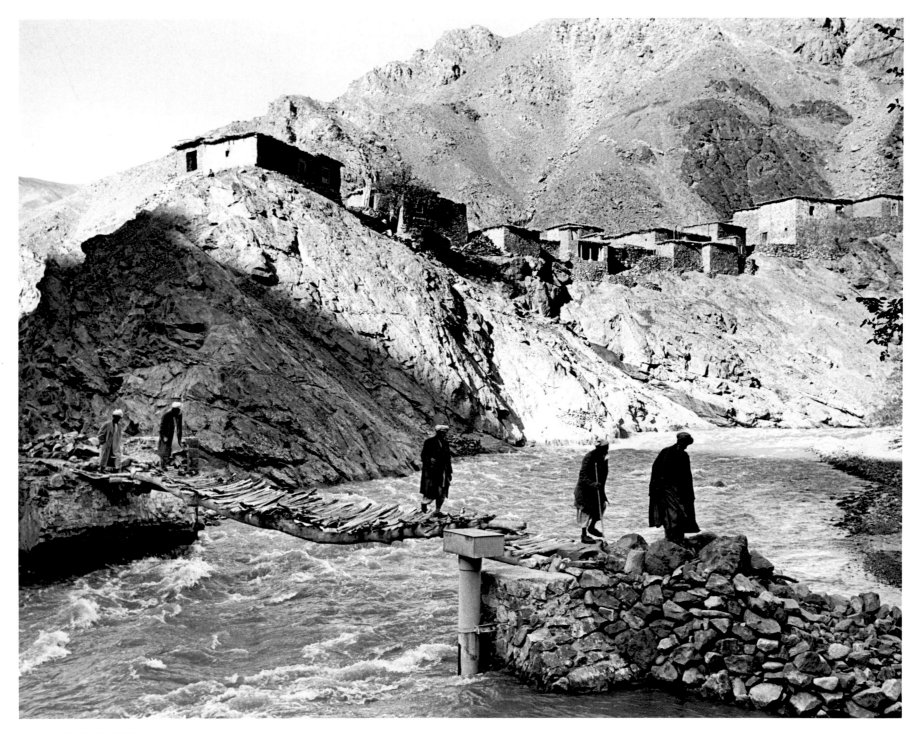

118. *Hindu Kush, Afghanistan, 1965*

119. *Kabul, Afghanistan, 1965*

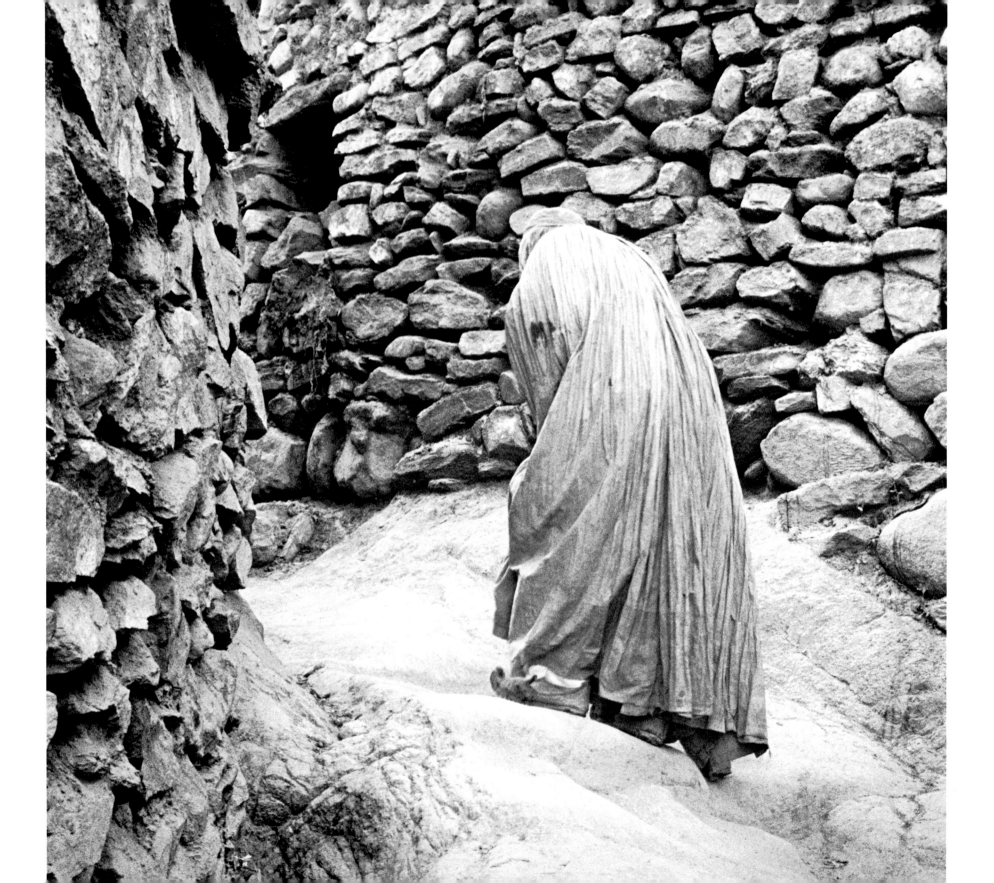

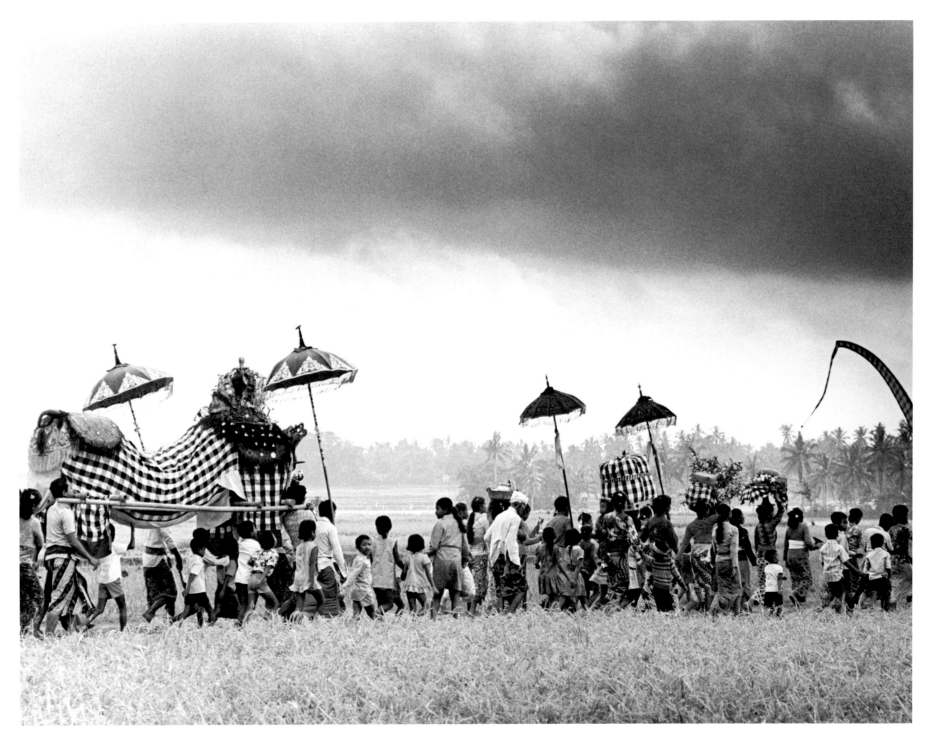

120. *Bali, Indonesia, 1974*

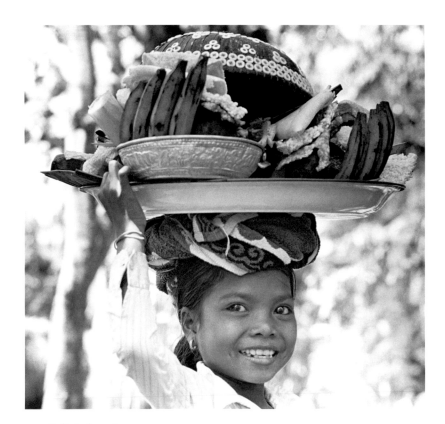

121. *Bali, Indonesia, 1974*

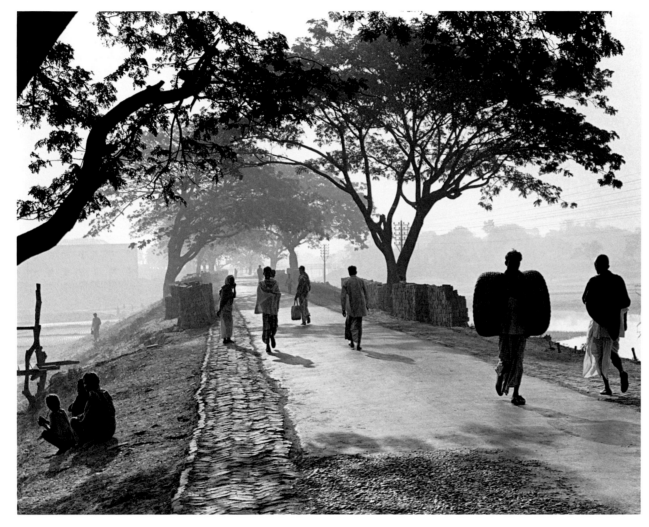

122. *Dacca, Bangladesh, 1972*

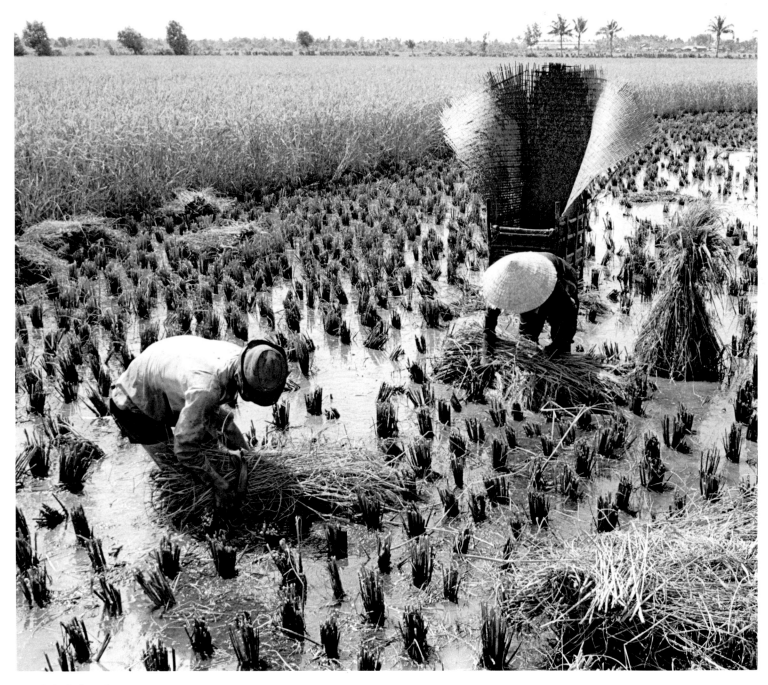

123. *Bali, Indonesia, 1974*

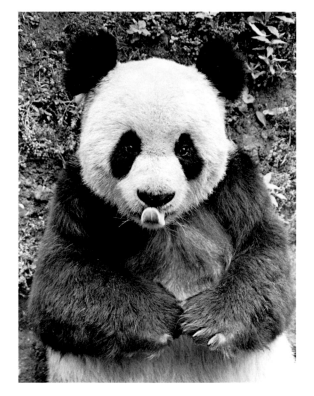

124. *Peking, 1980*

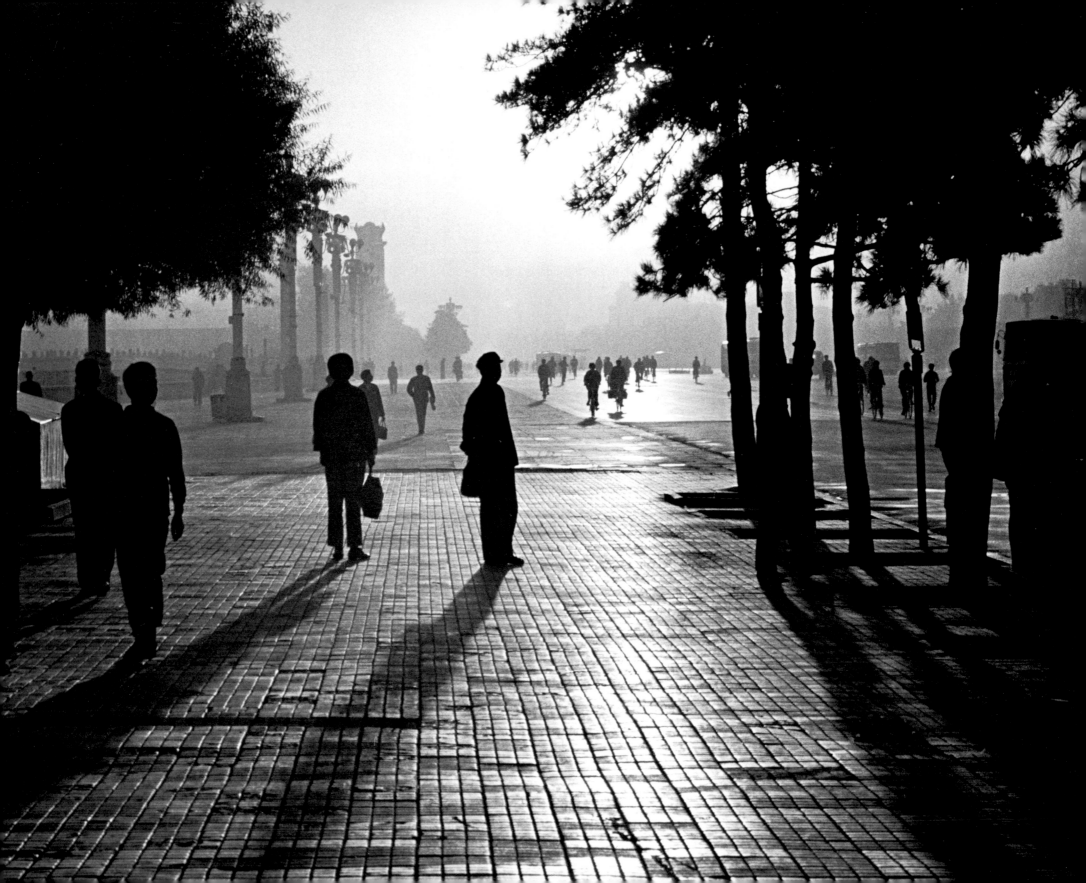

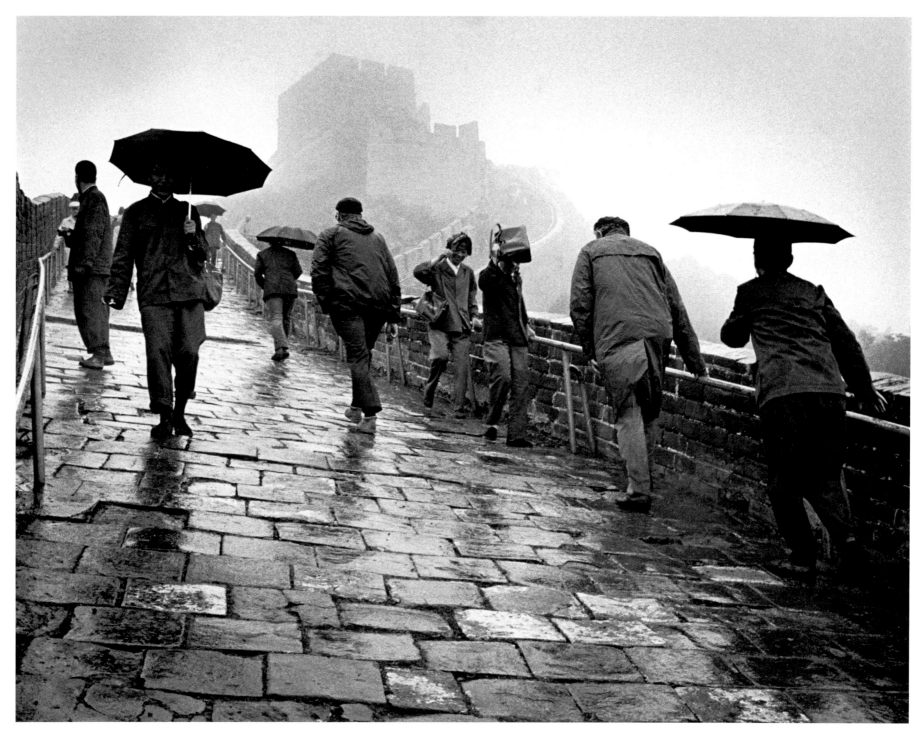

126. *The Great Wall, China, 1978*

The Great Wall is something every visitor to China wants to see.

With a busload of American newspaper editors I made the two-hour trip over winding and hilly roads from Peking. We arrived in pouring rain and heavy fog on a day that couldn't have been more dismal for photography. Because of the wet and cold weather most of the editors decided they could see the Great Wall just fine from the bus window!

In only a light jacket I started the steep, slippery climb alone. The higher I went, the heavier the rain, the denser the fog, but I finally reached the top. It was the highest point one could go at this stage of the 1,500-mile-long wall.

I was soaked and so was my camera – but this was China – and I was seeing what I had come here to see!

As I stood there trying to record the best pictures possible, I became aware of a figure close behind me; then something was very gently placed on my head. An elderly Chinese gentleman had observed my predicament and wanted to help. His wide-brimmed straw hat was now keeping the rain off my camera and out of my eyes. He smiled and I smiled back.

Within a few minutes, I moved in his direction to return the hat, but he had no intention of taking it back. It was a gift... for me to keep. Together we had spoken the universal language of love and understanding.

I still have that coolie hat with its bold Chinese markings – Commune Number 17.

Gordon N. Converse

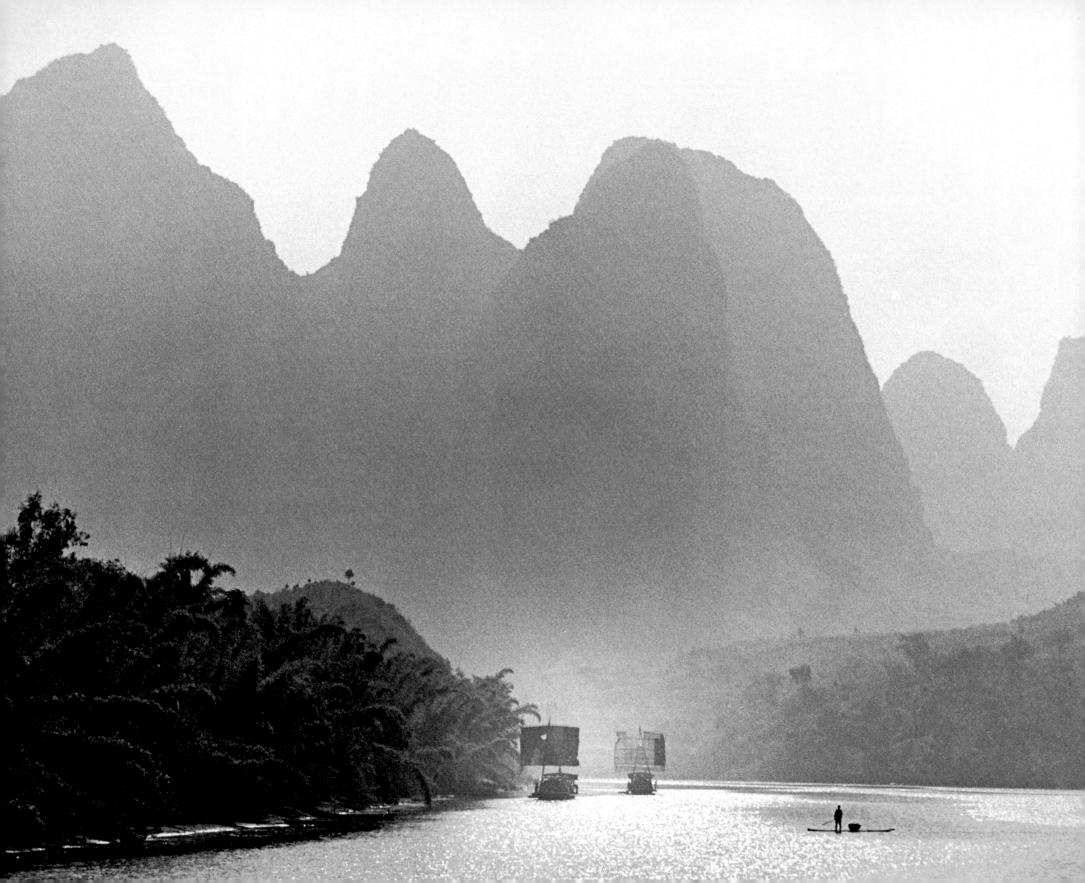

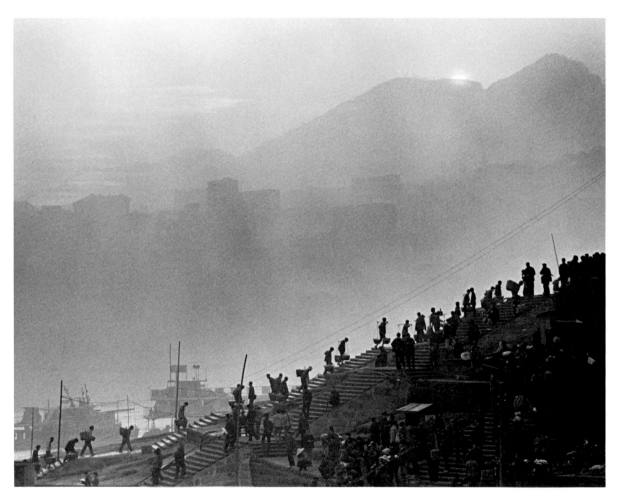

128. *Chongqing, Yangtze River, China, 1982*

127. *Guilin, Li River, China, 1980*

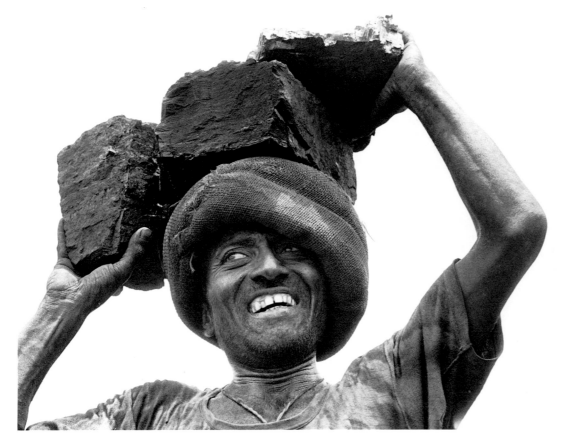

129. Bombay, 1972

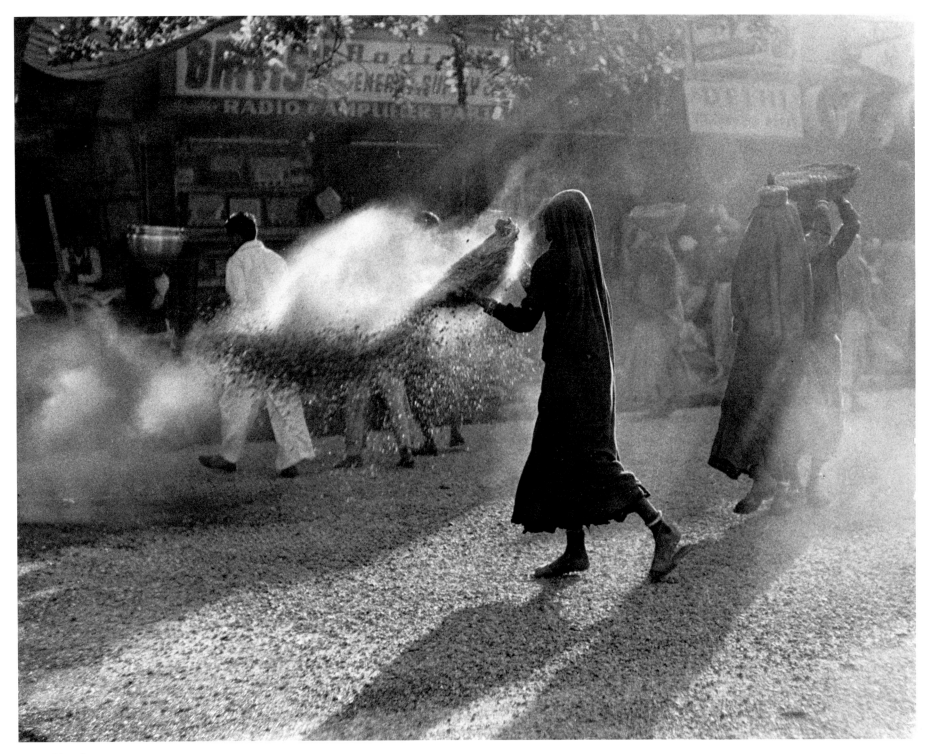

130. *Old Delhi, 1959*

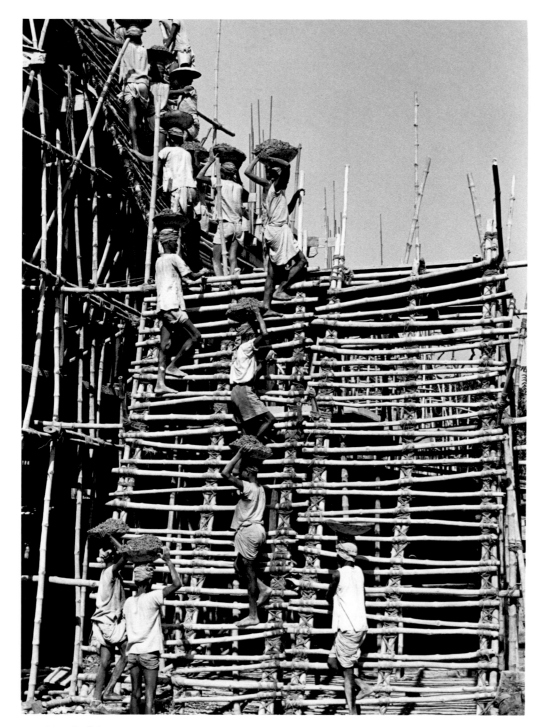

131. *New Delhi, 1959*

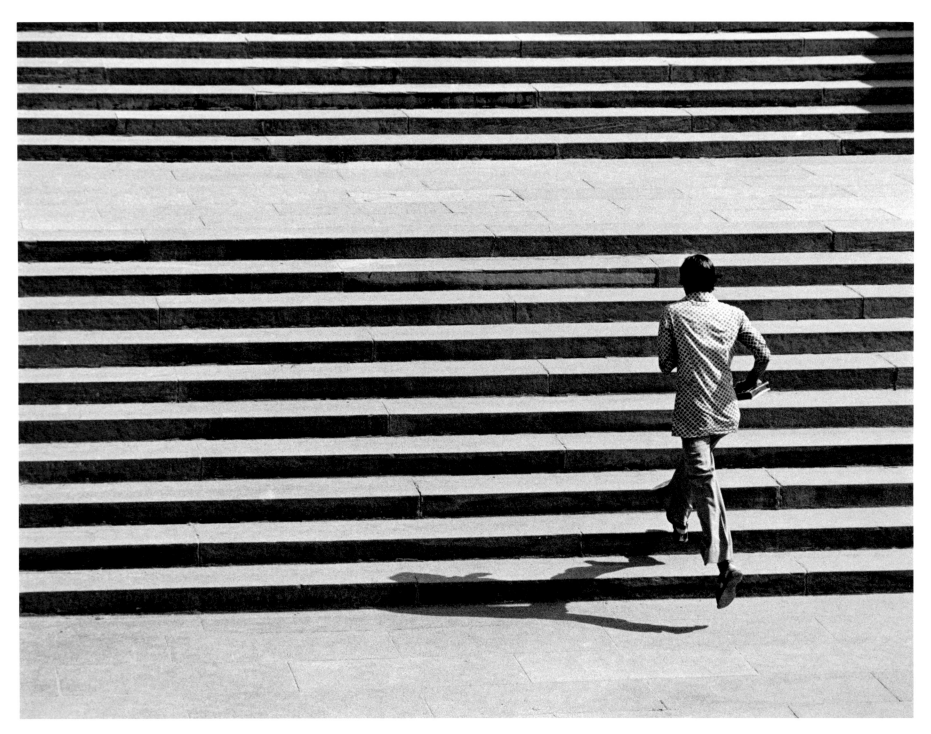

132. *New Delhi, 1978*

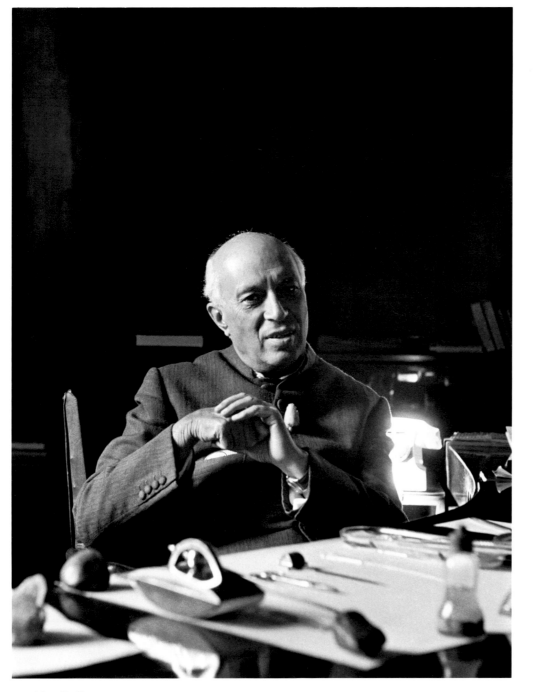

133. *New Delhi, 1959*

I have a desire to change India, but not to uproot it from its past. Something of value is acquired by a nation in its development — in its progress through millenniums of history.

JAWAHARLAL NEHRU

134. *Calcutta, 1972*

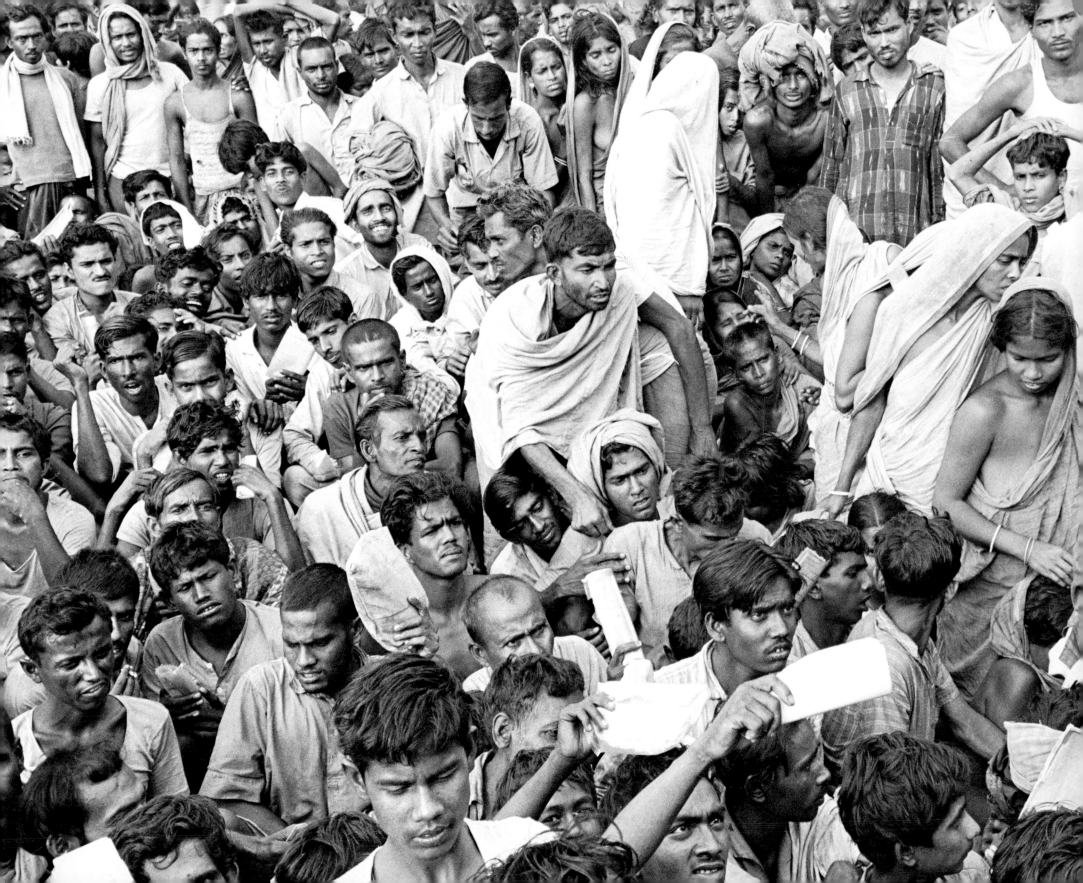

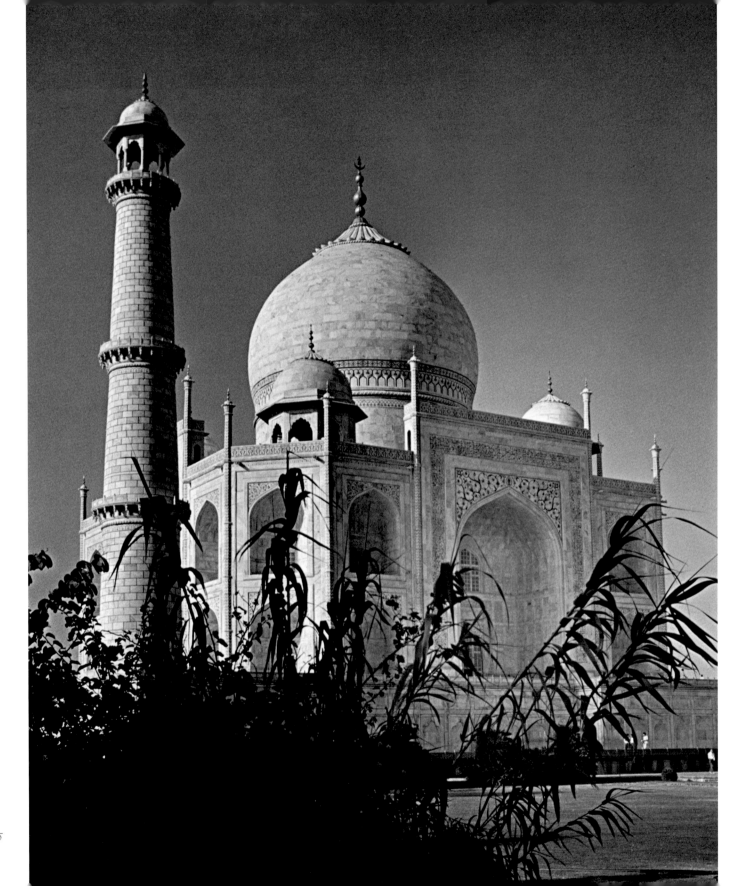

135. *Agra, India, 1965*

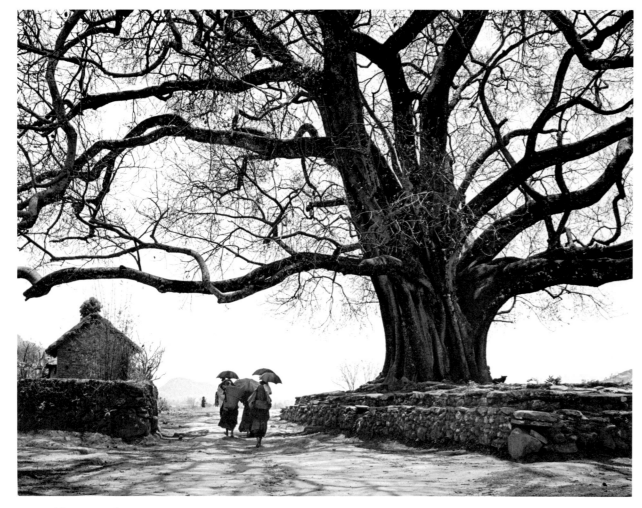

136. *Pokhara, Nepal, 1965*

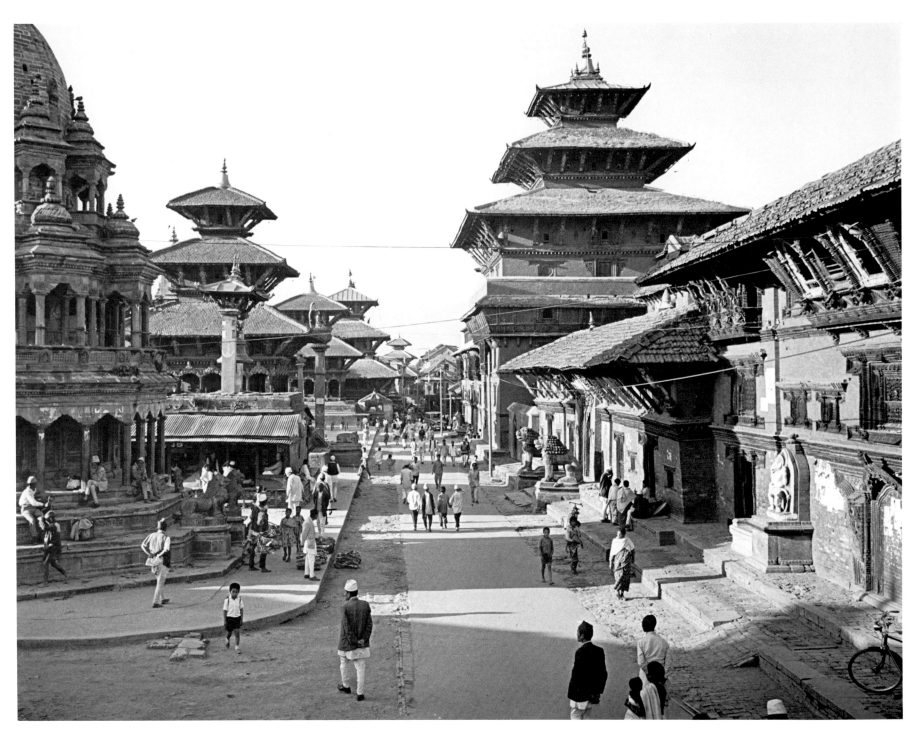

137. *Petan, Nepal, 1965*

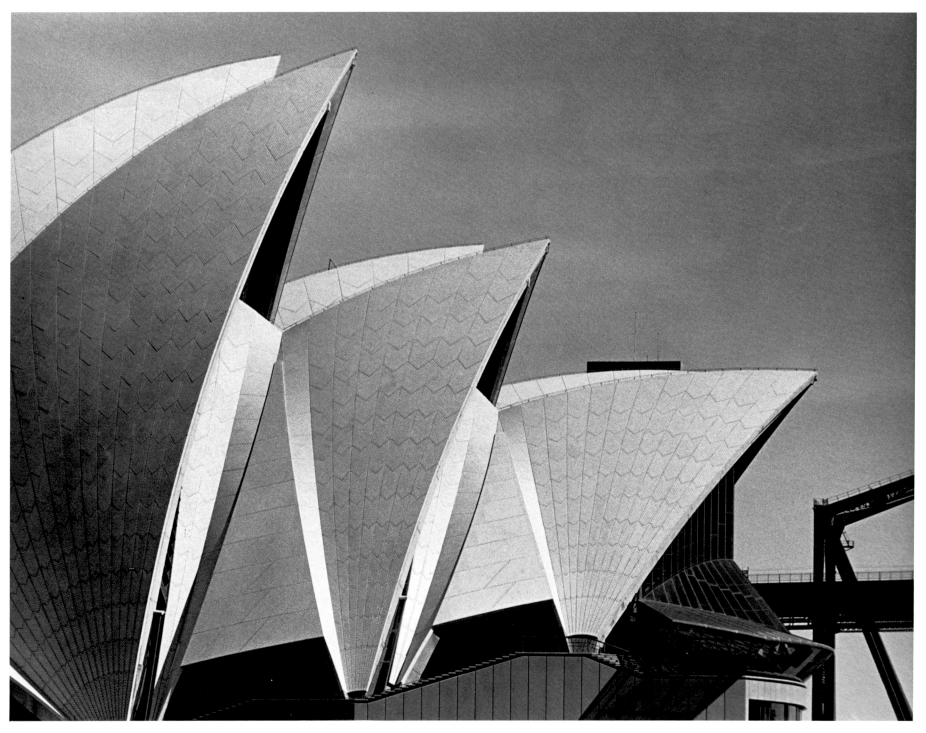

138. *Sydney, Australia, 1980*

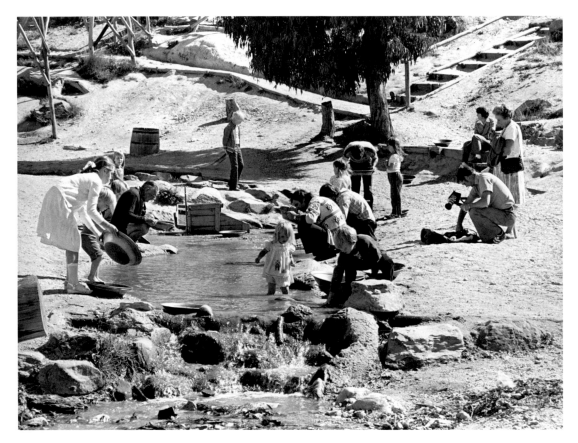

139. *Sovereign Hill Historical Park, Ballarat, Australia, 1981*

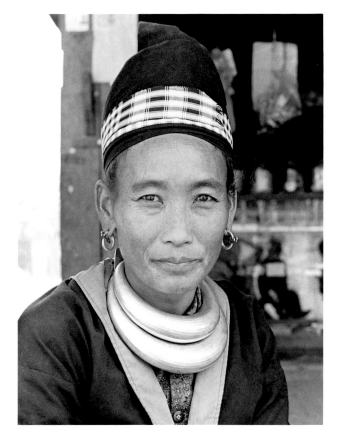

140. *Luang Prabang, Laos, 1972*

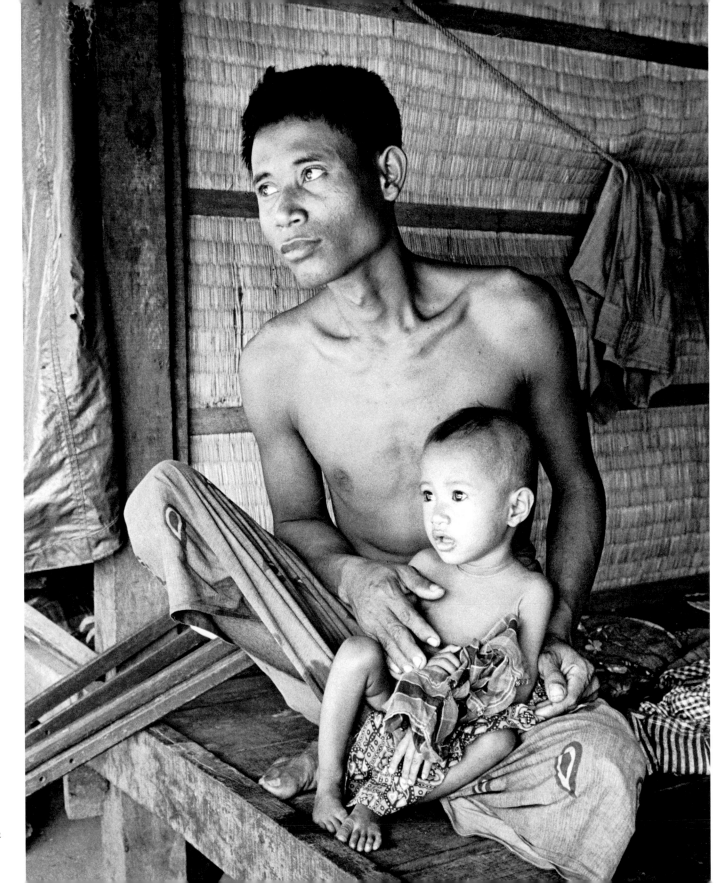

141. *Phnom Penh, Cambodia (Kampuchea), 1972*

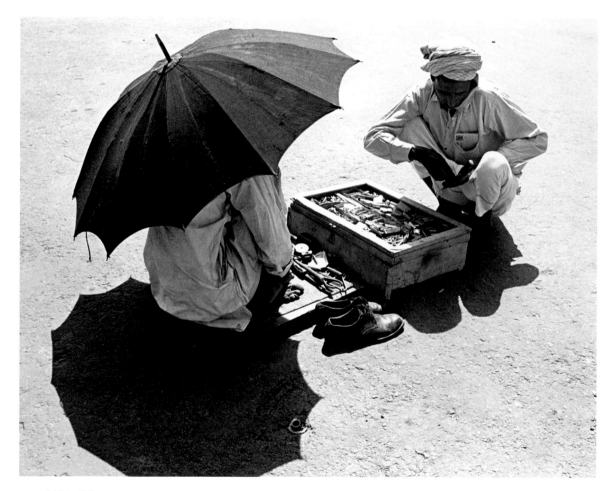

142. *Old Delhi, 1965*

143. *Punjab, India, 1978*

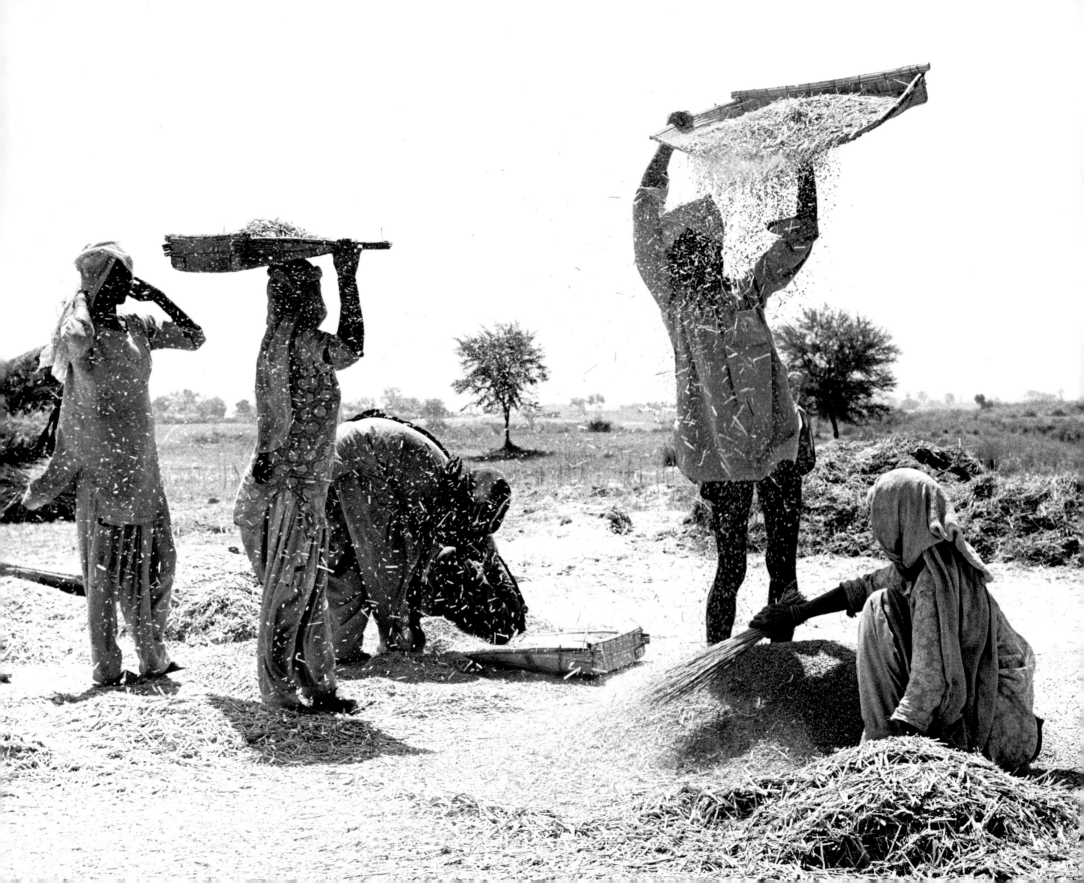

Right after one of the first snowfalls of the season I was walking down a muddy street along a ridge overlooking the Siberian city of Irkutsk when a pensioner suddenly appeared and asked the familiar, "Where are you from?" His president, he said, had told him to love everyone, and he interpreted that as a reason to invite me, a stranger, to his home.

His house was a typical solid log structure, clean and neat inside. A stove built into an interior wall heated the two rooms at a toasty level.

His wife was seated in the front room, where he proudly showed their collection of three icons. That university course which I took in his language some time ago didn't enable me to understand all of his story. However, I did learn that he had been in the army and there hadn't been any food during the siege. He had been retired for 13 years and was strong and lively.

As I thanked him and made motions to leave, his wife told him to offer me some cabbage soup. While I ate the soup and a huge slice of bread, she heated water for tea. Then he cut another huge slice of bread and, putting it beside the bowl, insisted, "Be sure to tell them we have plenty of bread."

They were genuinely friendly people and wonderful hosts.

When I again indicated that it was time to depart, he went all the way to the street with me, reluctant to release my hand, and after another round of well-wishing, he kissed my wrist and turned quickly away.

R. Norman Matheny

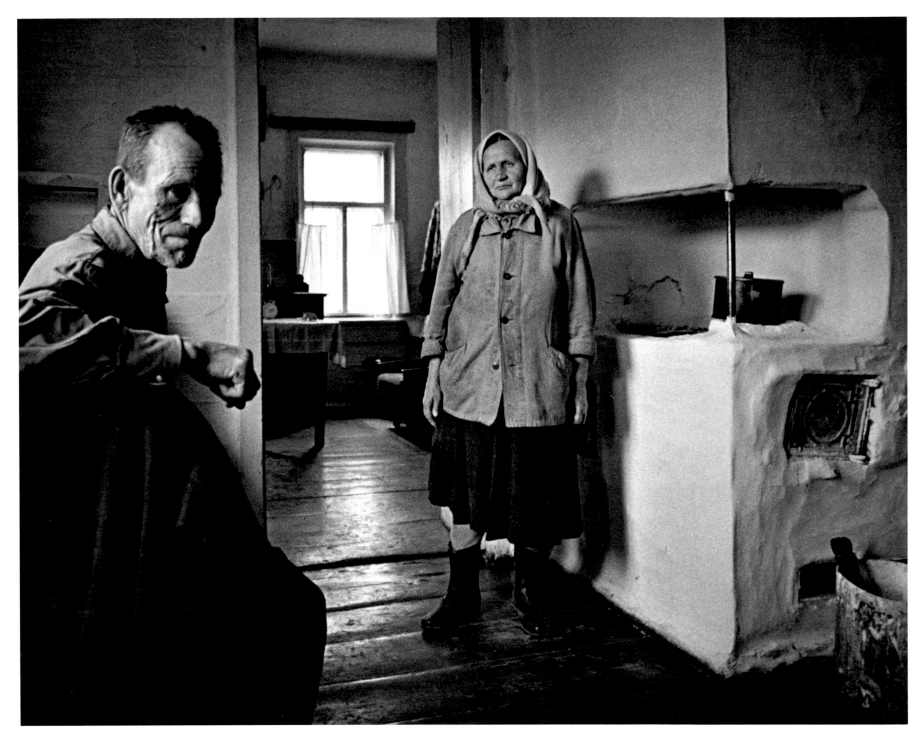

144. *Irkutsk, U.S.S.R., 1980*

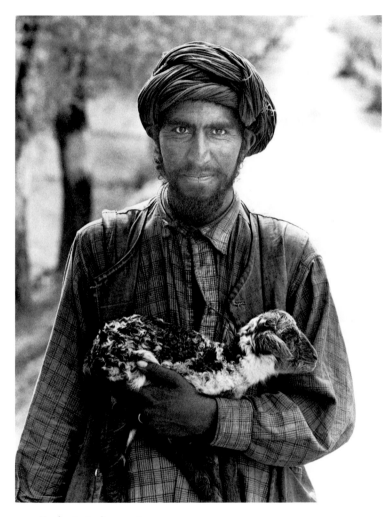

145. *Kashmir, India, 1978*

146. *Srinagar, Kashmir, India, 1978*

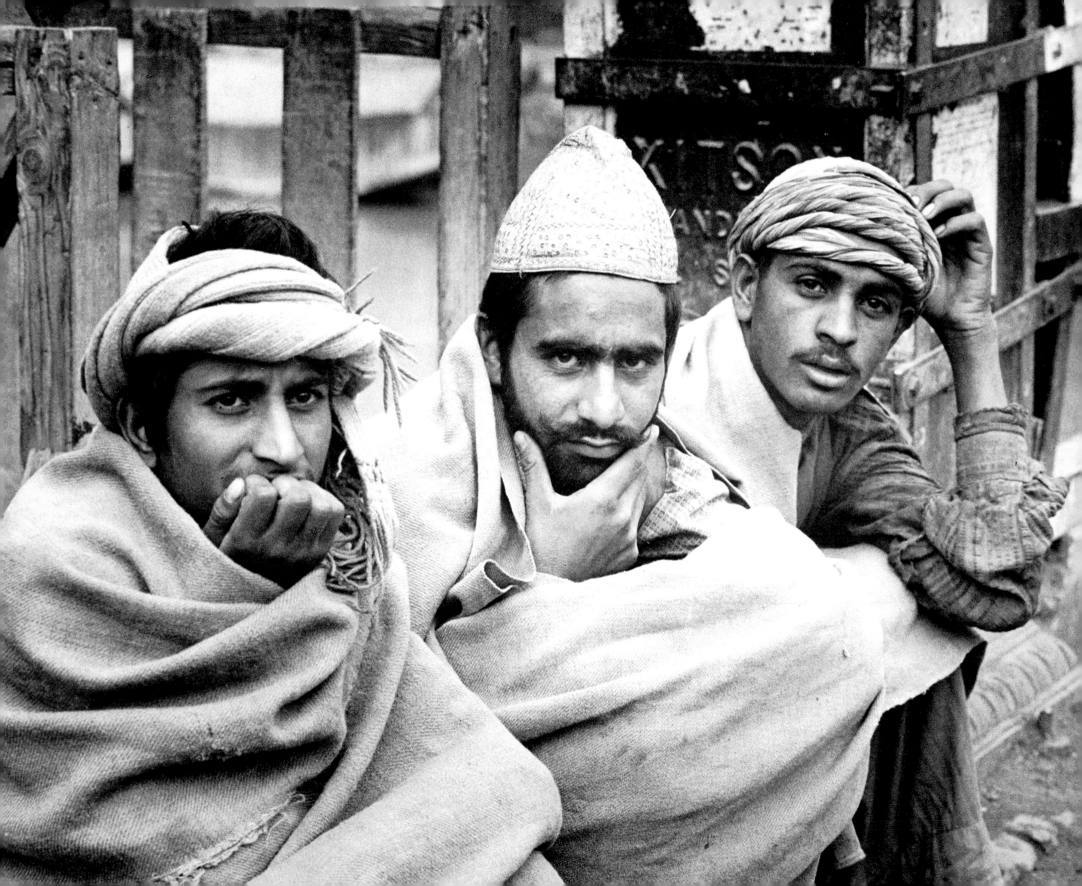

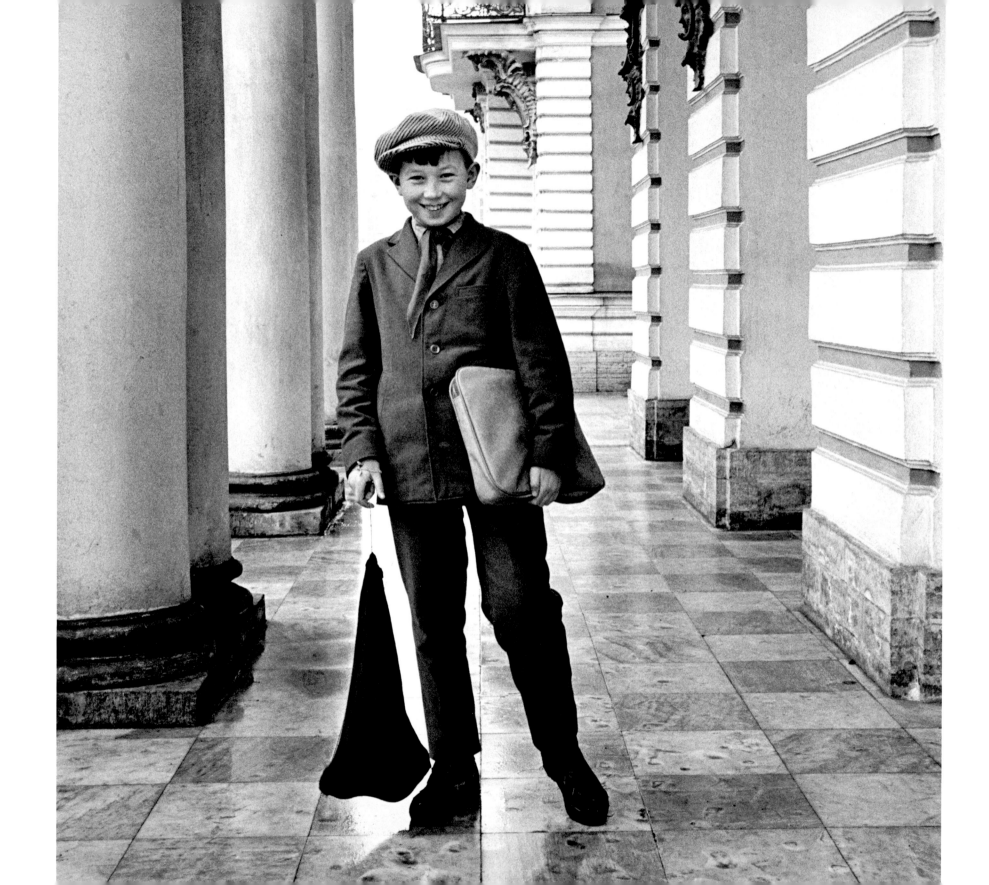

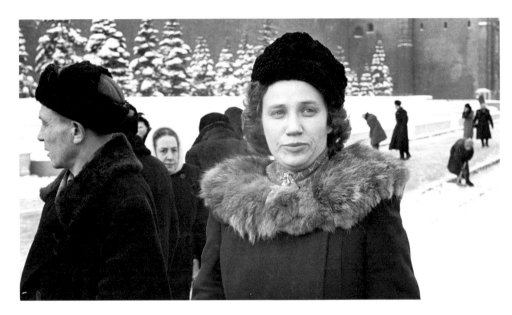

148. *Moscow, 1959*

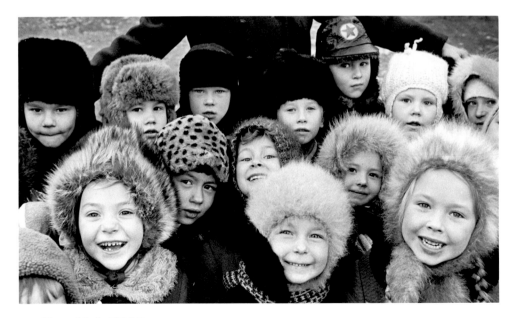

149. *Novosibirsk, U.S.S.R., 1979*

147. *Leningrad, 1967*

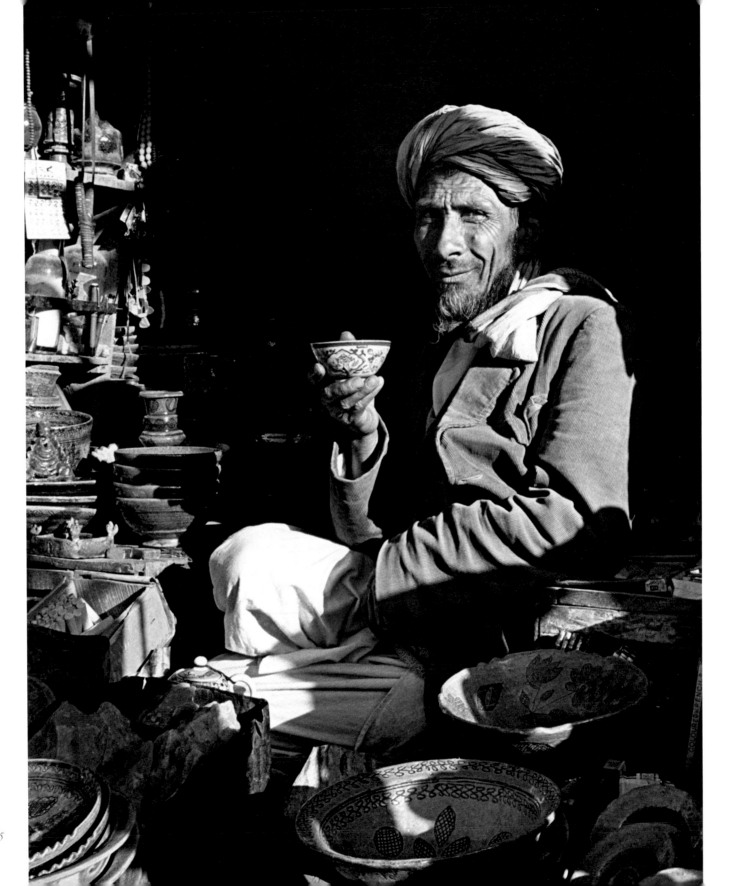

150. *Istalif, Afghanistan, 1965*

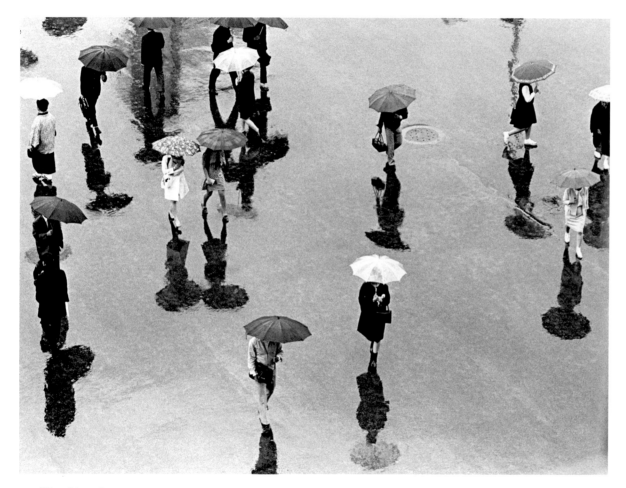

151. *Hiroshima, Japan, 1970*

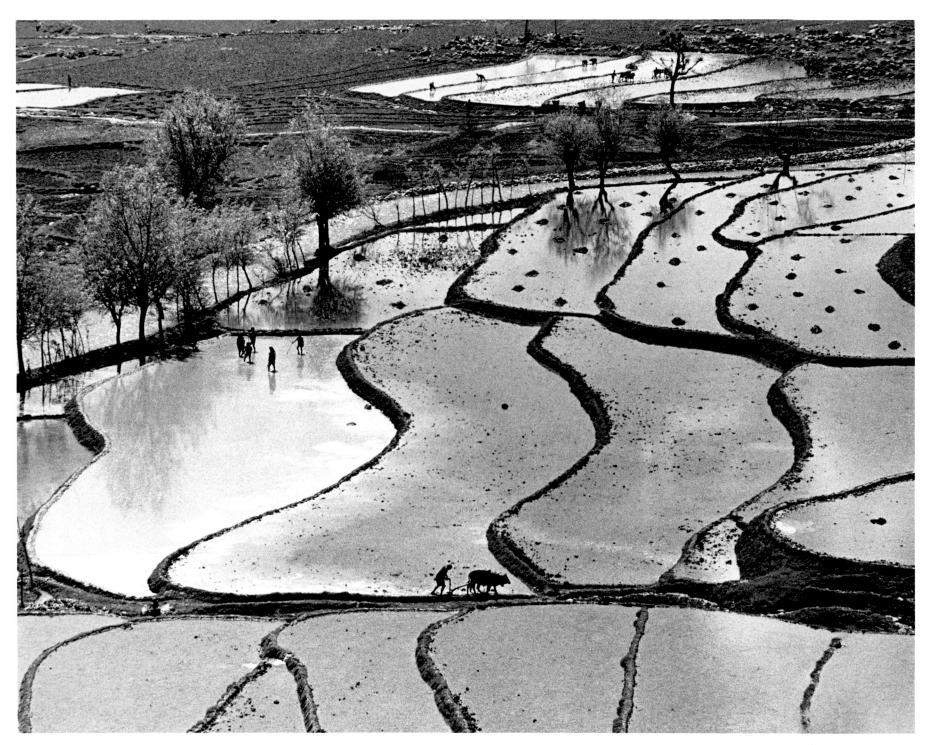

152. *Bali, Indonesia, 1974*

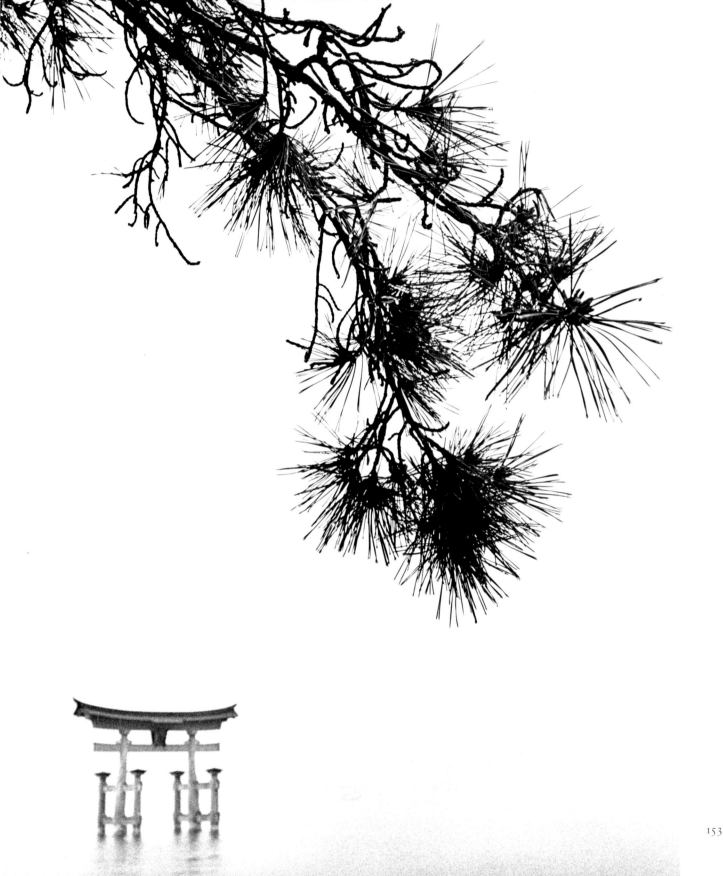

153. *Miyajima, Japan, 1970*

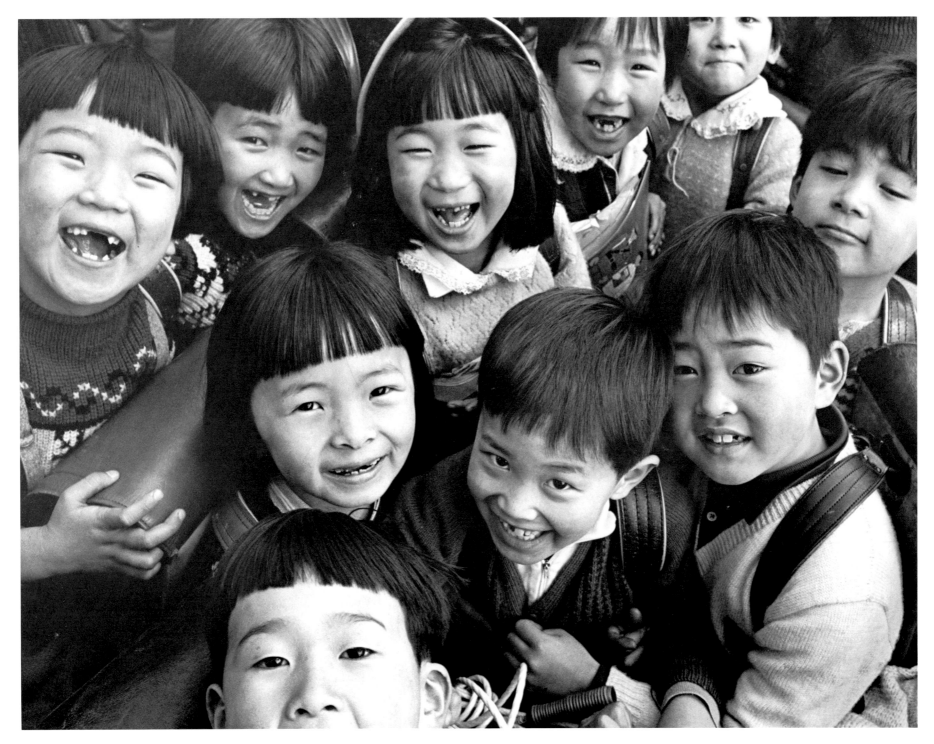

154. *Kyoto, Japan, 1974*

THE AMERICAS

1. Christmas shopping on Fifth Avenue.

2. Abraham Lincoln, the Capitol Rotunda.

4. First day of school and too scared to go through the big, closed doors, a first-grader lingers outside. The photographer, forgetting his deadline, united the young pupil with his teacher.

5. Hungarian refugees.

16. Trinity Church reflected in the John Hancock tower.

17. View from window-washing platform, sixty stories above the ground, as it maneuvers around a corner of the Hancock tower.

18-19. Sculpture honoring workers who built Brasilia (left) and Itamarati Palace—Brazil's Foreign Ministry.

21. Norway's *Christian Radich* hoists sail on parade.

22. Symbol of a celebration: the tall ship *Danmark* sends its crewmen into the rigging during New York harbor parade.

24-25. Indian women line the La Paz sidewalk to sell their wares. Perched at 12,000 feet, this city is the world's loftiest capital.

29-30. Secret sanctuary of the Incas, hidden from the world for three centuries under the shadow of Machu Picchu Mountain.

38. Lobsterman readies his traps.

EUROPE

52. The Acropolis.

53-54. The mountain village of Casares—high over the Mediterranean.

59-60. A medieval town overlooking the Tauber Valley.

62. Where fish have been sold for 700 years.

AFRICA AND THE MIDDLE EAST

65. Ghanaian fishing boats.

66. Unloading cement at Accra for the building of a new nation.

67. After a night of fishing and sailing, three fishing boats and a freighter prepare to land on the Ghanaian coast.

69. Karnak Temple.

71. A bronze-beating production line near Cairo's Mousky market.

72-73. University of Petroleum and Minerals—Science and Engineering Building.

74. Water towers.

79. A miller at work.

81. Veiled women sit in group at a sports event.

83. A ship-to-shore taxi.

86. An apprentice craftsman.

92. In what is known as Shepherds' Field far below the birthplace of Jesus, sheep still graze and rest as in ancient times.

93. The Wailing Wall.

94. Dome of the Rock, said to be the site of the threshing floor David bought and on which Solomon built the temple.

98. Main prayer hall of Vakil Mosque, Shiraz.

99. Baobab tree.

ASIA AND THE PACIFIC

102. Chinese swarm around a bus for a look at foreign visitors.

105. Child refugee studies in warehouse school.

107. A new arrival at the overflowing orphanage of Go Vap. The number on his forehead identifies his village.

109. Ban Xon, a tiny dusty airstrip tucked away in the mountains of Laos—a bustling refugee supply center for Meo tribesmen. Women refugees wait patiently, hoping for space on a returning plane.

112. Household birds hoisted aloft to enjoy the morning sunshine.

113. Street dwellers prepare their mid day meal.

116. U Nu, Burmese statesman.

123. Rice harvest.

128. The docks of Chongqing at dawn.

130. Women streetmakers sprinkle gravel in India's capital.

134. Pakistani refugees await return to their country.

135. From a quiet garden corner the Taj Mahal reaches its full glory.

137. Patan, an ancient art center near Katmandu, abounds in domed temples and pagodalike shrines.

138. The Opera House.

139. Panning for gold.

140. A proud refugee from the mountainous north.

141. Cambodian refugee and his son—all that he has left.

PHOTOGRAPH CREDITS

GORDON N. CONVERSE: 2, 4, 5, 9, 10, 12, 14, 15, 17, 18, 19, 20, 24, 25, 26, 27, 28, 29, 30, 32, 34, 35, 36, 38, 39, 40, 42, 43, 44, 45, 47, 48, 49, 50, 51, 52, 53, 54, 55, 56, 57, 58, 59, 60, 61, 62, 63, 64, 65, 66, 67, 68, 69, 70, 71, 72, 73, 74, 75, 76, 77, 78, 79, 82, 83, 84, 85, 86, 87, 88, 89, 90, 91, 92, 93, 94, 95, 98, 99, 100, 101, 102, 103, 104, 105, 106, 107, 108, 109, 110, 111, 112, 113, 114, 115, 116, 117, 118, 119, 120, 121, 122, 123, 124, 125, 126, 127, 128, 129, 130, 131, 132, 133, 134, 135, 136, 137, 138, 139, 140, 141, 142, 143, 145, 146, 147, 148, 150, 151, 152, 153, 154. R. NORMAN MATHENY: 3, 13, 80, 81, 96, 97, 144, 149. PETER MAIN: 33, 37. BARTH FALKENBERG: 1, 6, 7, 8, 11, 16, 21, 22, 23, 31, 41, 46.